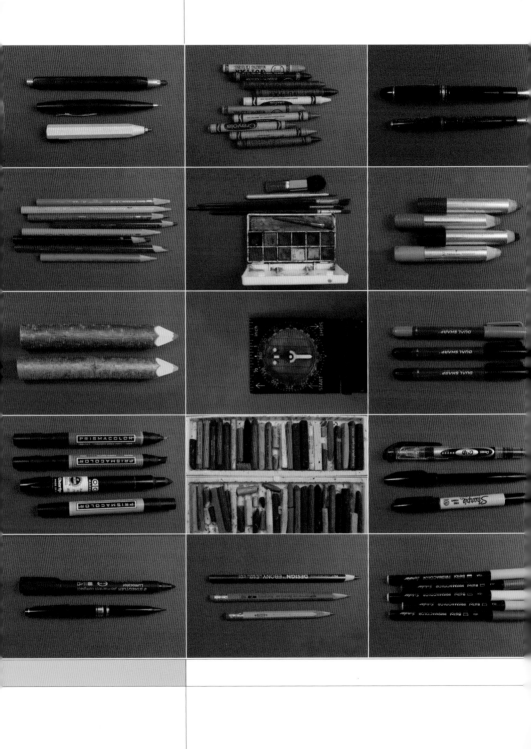

draw it.

Tools · Techniques · Methods

A workbook manual for sketching + drawing

Lynn Craig, FAIA, RIBA
Architect

EDITIONS

Workbook Images:
Lynn Craig, FAIA, RIBA

Workbook Layout
and Design:
Cary Perkins, AIA

Publishers of Architecture, Art, and Design
Gordon Goff: Publisher

www.oroeditions.com
info@oroeditions.com

Published by ORO Editions

Draw It – Tools, Techniques, Methods
A Workbook Manual for Sketching and Drawing

Workbook Images: Lynn Craig, FAIA, RIBA
Layout and Design: Cary Perkins, AIA
Text: Lynn Craig FAIA, RIBA
Cover Design: ORO Editions
Project Coordinator: Lynn Craig FAIA, RIBA
Project Co-Coordinator: Julie Craig

10 9 8 7 6 5 4 3 2 Second Edition

Library of Congress data available upon request. World Rights:
Available

ISBN: 978-1-941806-76-0

Color Separations and Printing: ORO Group Ltd., Printed in China.

International Distribution: www.oroeditions.com/distribution

ORO Editions makes a continuous effort to minimize the
overall carbon footprint of its publications. As part of this goal,
ORO Editions, in association with Global ReLeaf, arranges to
plant trees to replace those used in the manufacturing of the
paper produced for its books. Global ReLeaf is an international
campaign run by American Forests, one of the world's oldest
nonprofit conservation organizations. Global ReLeaf is American
Forests' education and action program that helps individuals,
organizations, agencies, and corporations improve the local and
global environment by planting and caring for trees.

AMERICAN FORESTS
Protecting & Restoring Forests

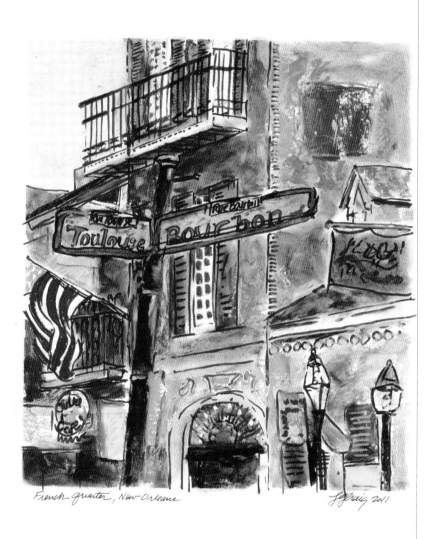

French Quarter, New Orleans

LJCraig 2011

Gray Tones

black and white

color

paper Types and Drawing Equipment

Helpful color bar guides to locate **Tools, Techniques, and Methods** in the workbook:

For quick location of chapter subjects, look for the color bars at the bottom of each page.

1. why freehand drawing?

2. Tools + Techniques

Methods

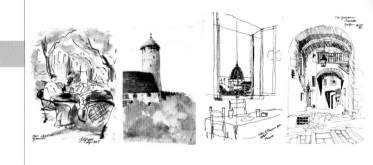

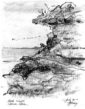

Drawing as a way
of Thinking

3. Methods

4. Drawing as a way of Thinking

> To develop and expand your visual vocabulary

> To develop your visual skills at reading the built and natural landscape during your journeys

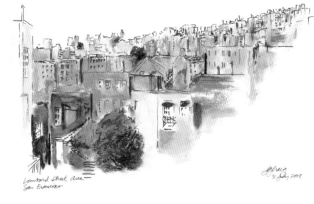

Lombard Street area—
San Francisco

1. why freehand drawing?

The freehand sketches and drawings in this workbook are all by the author over a span of forty years, using a wide variety of drawing tools and media. As a result, the "look" of the drawings take on their own personalities and appearances. Ninety percent of the drawings are completed on-site, whether outside standing on an urban sidewalk, or inside while drawing in a cafe where patrons are discussing the latest sporting event. The remaining ten percent are finished in a controlled studio environment.

On the following pages an array of drawing tools are demonstrated, illustrating a variety of drawing techniques which can be achieved with each tool. The last chapter is dedicated to drawing methods which can be used to communicate your design ideas.

This book is crafted to be a companion tool which is tucked into your travel gear and used regularly. The book is durable and referenced to give you an immediate source of inspiration. Your "bag of tools" will become your friends as they become an extension of your hand and eye. So then, what are you going to do with that image you just drew in your sketch book? It doesn't matter if it just stays there for future reference. What is important is that the image is now also stored in your memory.

Why freehand drawing? Let's look at two fundamental reasons why drawing using only your hand and eyes is a valuable skill. First, you sketch your freehand drawings to develop and expand your visual vocabulary. Second, you draw to develop your skills in reading and recording the built and natural landscape during your journeys.

Now, go out, unfold your canvas sit-upon, open your shoulder bag, and grab a tool, any drawing device. Start looking and drawing simultaneously, and experience the joy of discovering the emergence of your freehand drawing and understanding the place around you.

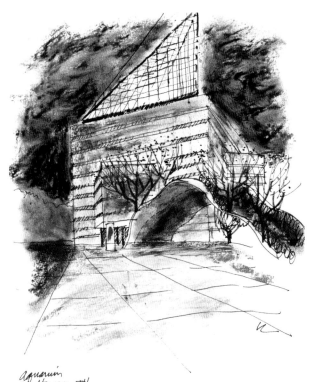

aquarium
Chattanooga, TN
4 Sep. 2008

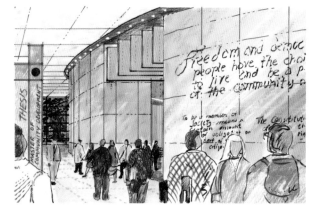

Introduction:
How to use this workbook

This drawing book is intended to be very much like a workbook manual, showing what drawing tools are available for you to use in a variety of settings, examples of different techniques achieved by each tool, and depicting a range of drawing methods demonstrated to capture a basic visual idea.

Each of the chapters is color-coded, using the color bar located at the bottom of all of the pages for quick and easy reference. So, if you are out on the street and you want to learn how to do a black and white pen drawing, you would pull out this small, pocket-size book, flip to the pages coded with a black bar at the bottom, and see examples of what can be achieved with the pen.

Throughout the pages of this "How-To" book are examples of quick sketches, where your time is a very limiting factor. There are also examples of what I call drawings, images that may begin as a sketch on-site, then developed in a controlled environment, like a design studio or office, where sufficient time is allowed to transform the sketch into a drawing.

Acknowledgements

We learn from the masters who have influenced our ability to observe and truly see the world around us. We slowly develop our own particular drawing skill as a signature style. We meet the masters through studio settings and by poring over as many books as we can find, studying their variety of drawing methods and tools.

My drawing heroes are many, but in particular I wish to acknowledge: Antoine Predock, FAIA, for his introduction to the sable point brush pen and oil pastel; Gordon Cullen, for his urban design theory of serial vision, as illustrated in "Townscape"; Helmut Jacoby, for his incredibly detailed rendered illustrations; Professor Ireland Regnier, for teaching me color and the power of cobalt blue layered over lamp black; and John Jacques, AIA, for his ability to draw and inspire.

from your inventory of travel analysis sketches...

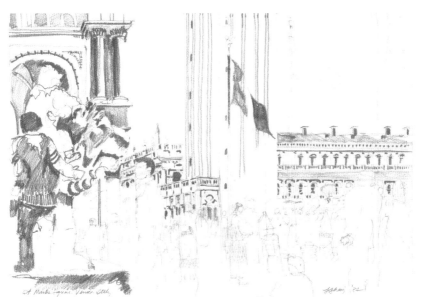

Travel analysis sketch

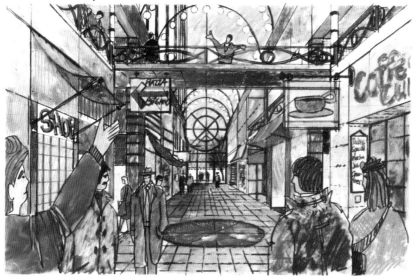

proposal drawing

To studio proposal drawings...
 This is the intent of this workbook manual.

2. Tools + Techniques

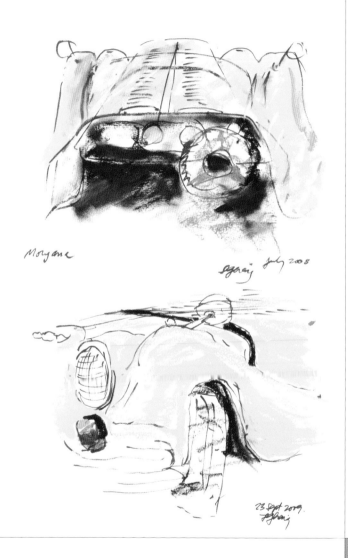

Morgana

Sgraig July 2008

23 Sept 2009.
Sgraig

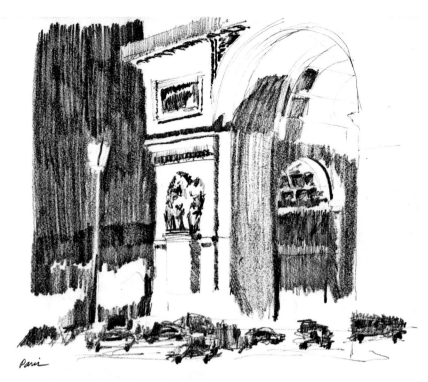

Paris

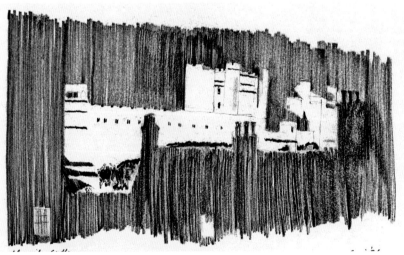

Night drawings are fun because they are the reverse of daytime images...

Gray Tones

We start our drawing journey with the simplest, most uncomplicated tool – the pencil. That cedar barrel stick with soft graphite lead, sometimes celebrated with a brass and rubber eraser cap, is a perfectly good tool. The interesting thing about the lead pencil is that as you use it, the graphite point slowly wears down, offering a broad line. If you take a knife or sandpaper to the point and make a chiseled edge, then you can cover a white sheet of paper with solid black in no time.

Very subtle nuances can be achieved with the pencil stroke, from heavy, vertical lines creating night images and tree canopies, to lighter, soft strokes creating delicate tonal drawings, where your drawing lines are all but eliminated.

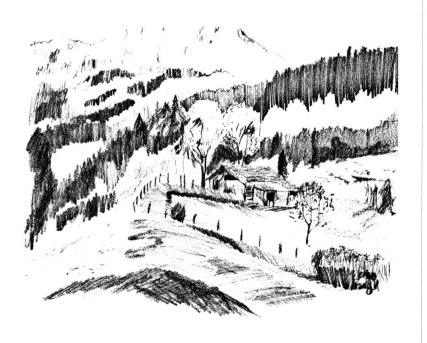

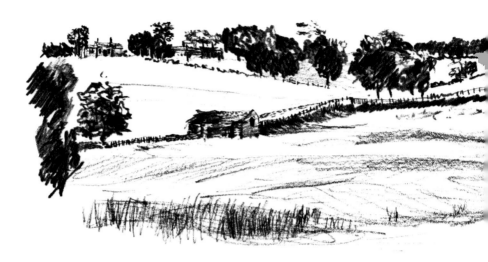

Malham, Yorkshire

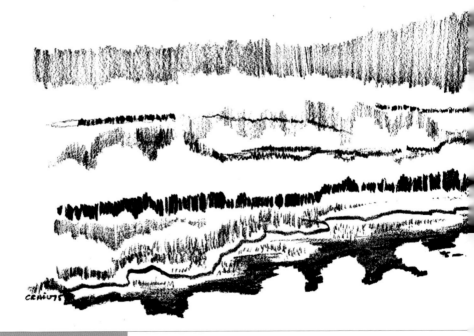

CRAIG 75

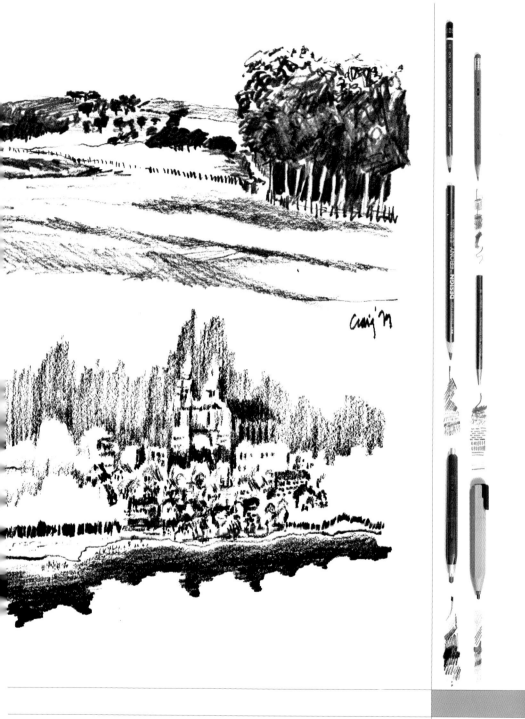

Craig '??

The intensity of graphite lead is incredible...

Carbon graphite leads come in a range from very soft, like 6B, to very hard, like 6H. Most of your pencil sketching in a sketch book will be in the range of 6B to 2H (2H is the standard yellow pencil). But, there is a world of pencils out there, from the well-known shortie to the chisel edge carpenter pencil.

The potential range of dark intensity is what makes the pencil a great drawing tool – it is so uncluttered and uncomplicated.

Take a close look at these pencil sketches and see the wide range of tone, texture, and materiality that can be achieved: smooth stucco walls, stone garden walls, terra-cotta tiles, and grass.

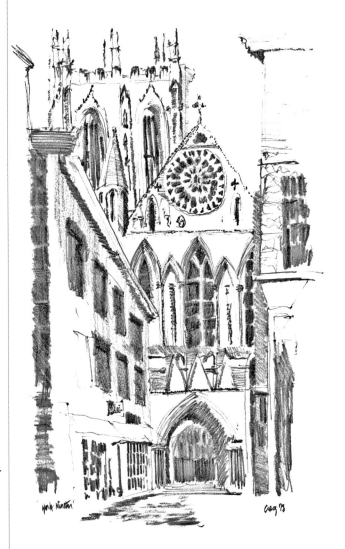

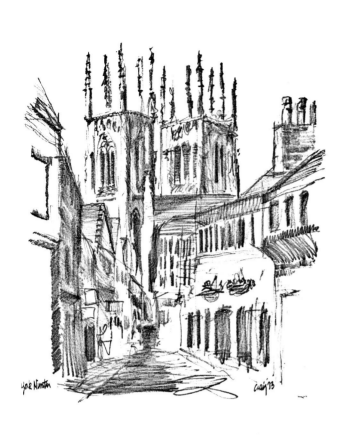

York Minster

Craig 73

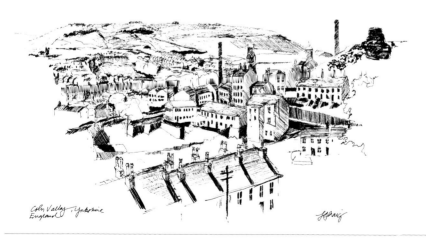

Coln Valley, Yorkshire
England

Craig

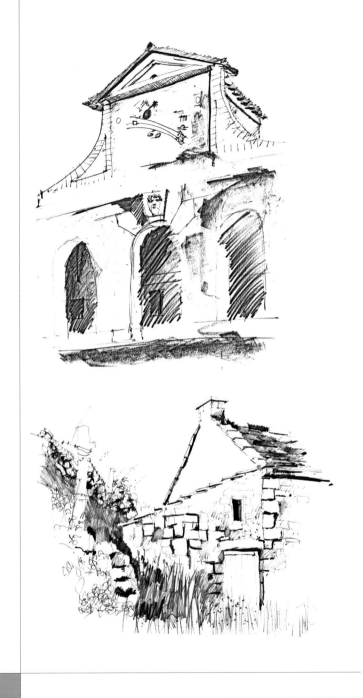

Roofscapes make the place memorable...

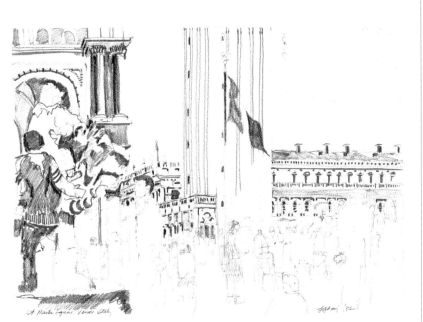

pencil sketch in early development style

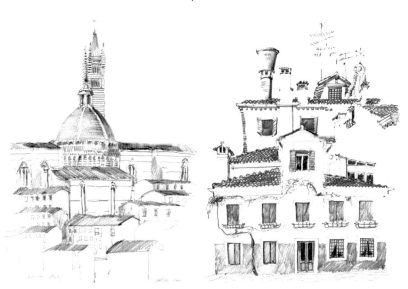

You should travel with a variety of sketch book sizes, as some of your images will fit nicely onto one page of a sketch book. But, do not ever limit the size of your sketch or drawing to the size of the paper at hand. Draw on, and just continue your sketch onto another page.

Later, return to the drawing and with a sharp knife and straight-edge, cut the drawing at the overlap, and place clear tape or tape dots on the reverse side of the drawing. Now you will have a good sized drawing.

Do not be concerned about the binder crease separating the images. The image is for you, to load to your memory bank for future reference.

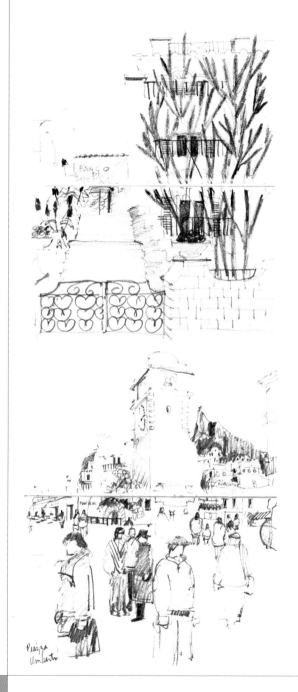

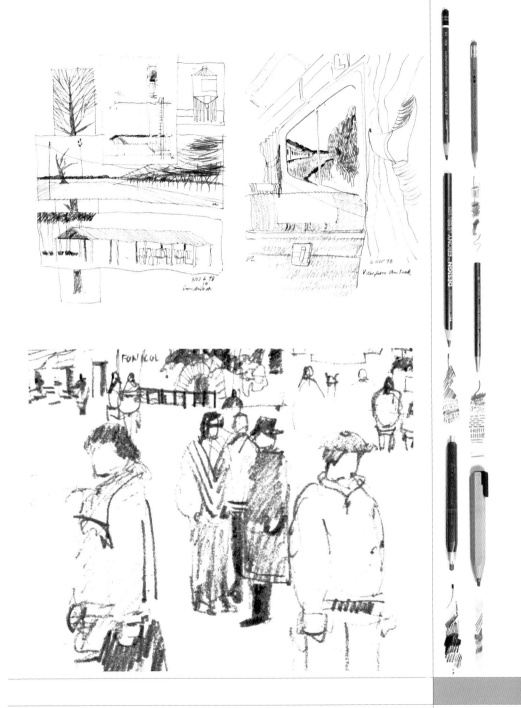

soft 6b lead allows images to be drawn quickly with light-
handed strokes and heavier pressure, producing intense,
dark areas.

The technique of drawing one-point perspectives, combined with site plans and building sections, provides you with a more complete analysis and understanding of the PLACE you are visiting.

A good characteristic of the carbon pencil is that it does not smear easily, and you can erase areas if you set up your view incorrectly. Drawing one-point perspectives is later explained in Chapter 3, *Methods*.

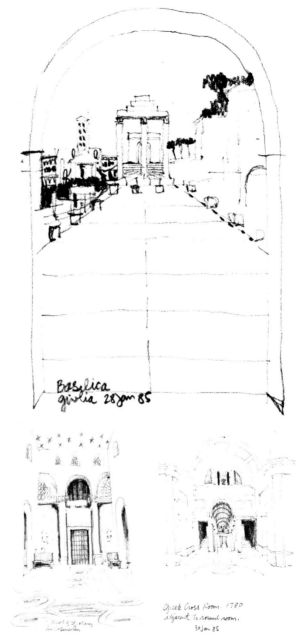

Basilica
giulia 28 Jan 85

Greek Cross Room. 1780
adjacent to round room.
30 Jan 85

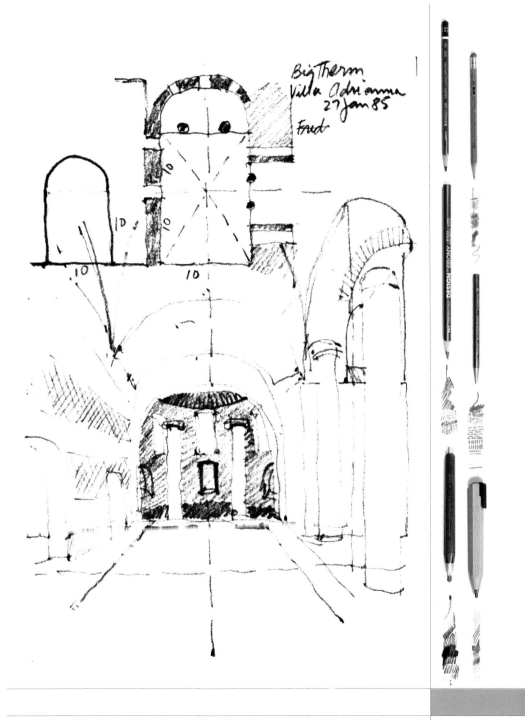

BigTherm
Villa Odrianna
27 Jan 85

Fred

Other interesting tools in the pencil range are the wax pencil and china marker. The wax pencil by Staedtler, the Mars-Lumograph 100 EB, is used here in the small demonstration sketch and the following illustrations, showcasing its versatility.

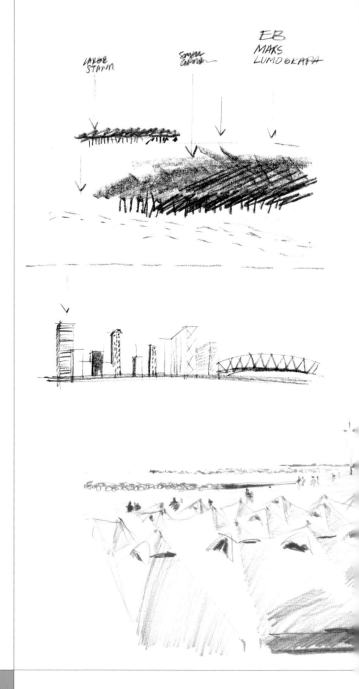

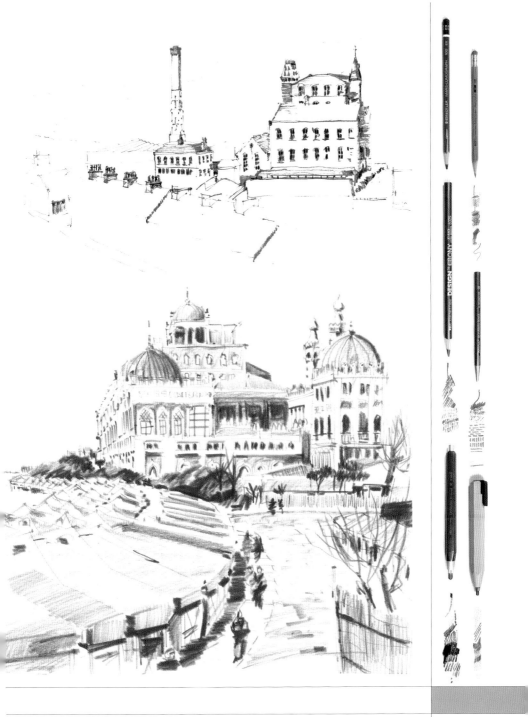

black wax pencil provides sharp lines and intense black areas as shown in this site sketch of Murano, Italy.

16

When you combine the wax pencil with a soft carbon lead, you can achieve a broad range of tone, subtle detail, and visual impact of drawing dark accent areas. Notice the high areas of contrast achieved by adding hand pressure to the drawing tool.

In some situations, you may not have time to do a sketch at all, and the only thing left to use is your camera or iPhone. So, take the images, print and enlarge them for reference, and draw it later.

An age-old method of learning drawing technique is positioning yourself in front of an artwork you admire and drawing that artwork as a facsimile of the original. This method of "learning from the masters" goes back to the early development days of a young intern joining the master in his studio and learning first-hand the tools, techniques, and methods of that craft, be it painting, sculpture or architecture.

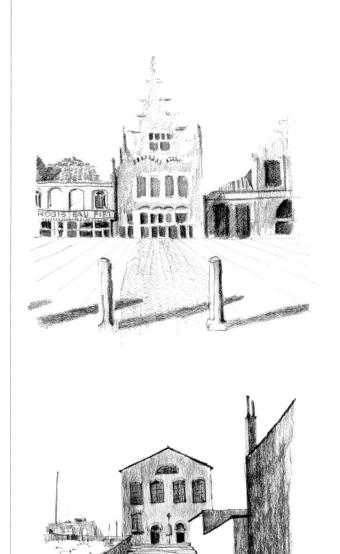

learn from your drawing heros...
Gordon Cullen... Andrew Wyeth...

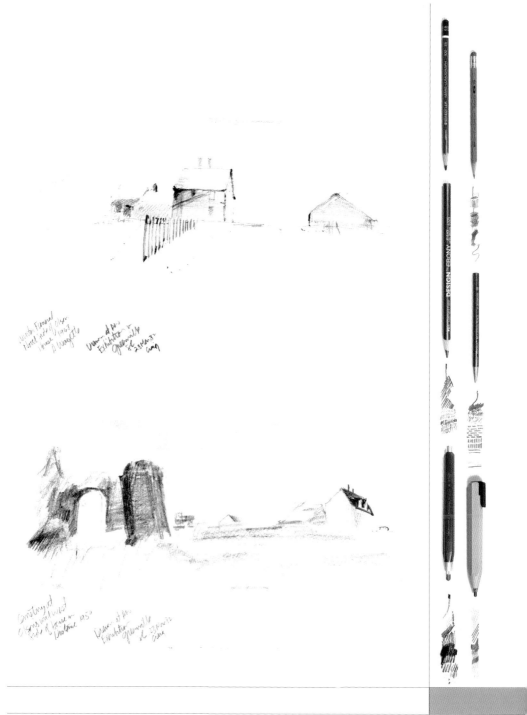

These examples show a drawing first constructed using a Rapidograph pen (point 0), drawn on white vellum paper, then using the wax pencil to tone in the building form and capture the materiality of the English street.

Overlay 11"x17" photo with trace paper or mylar film, using Rapidograph pen and wax pencil.

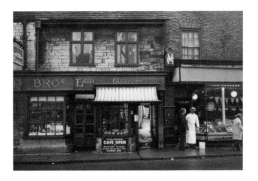

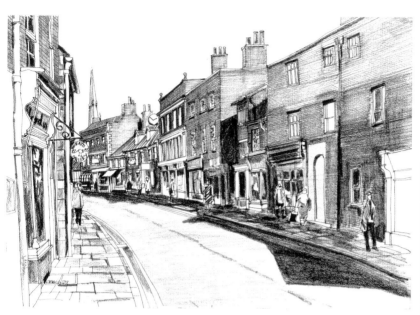

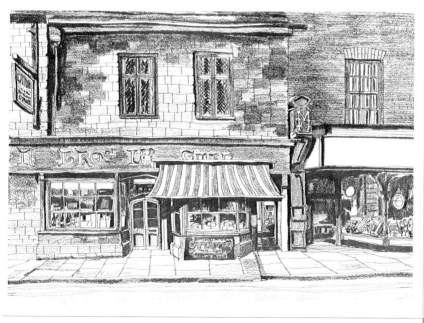

overlay the photograph with vellum or mylar film, draw with
pencil and wax pencil. Draw the detail of the passage...

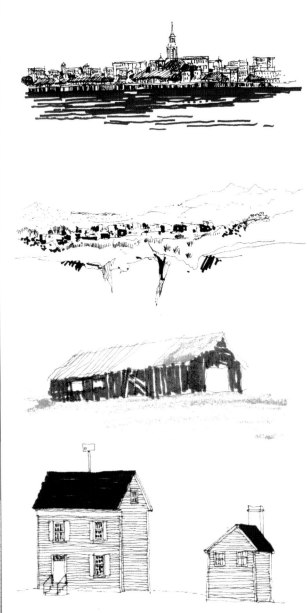

black and white

The fountain pen, roller-ball pen, felt tip marker, Pentel Sign Pen, and Sharpie fine and medium points are all pens ready for your use, and ought to be in your travel bag or shirt pocket.

Combining the roller-ball pen and Sharpie marker provides an opportunity to take a rather quick sketch and turn it into an image with strong impact, due to the adding of large areas of black, as seen in the roof shapes and river water.

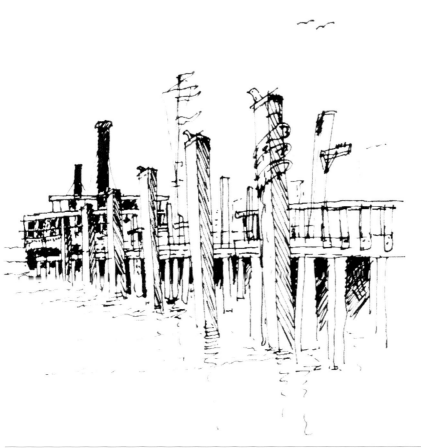

black sharpie... perfect for dark, black areas and shadows.

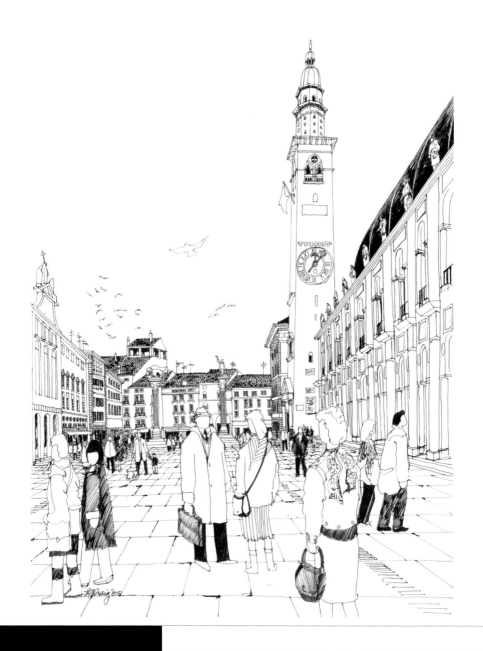

people in winter jackets add a sense of
the season...

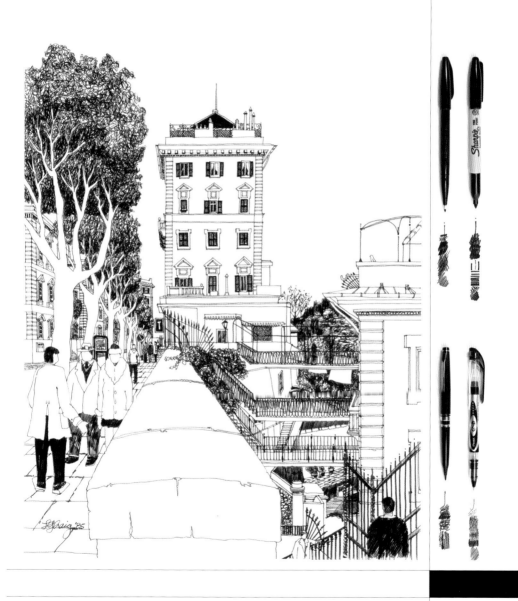

looking up and looking down in a drawing is
demonstrated in chapter 3.

The black and white pen drawing can start out as a pencil draft, where you should not be concerned about your construction lines crossing over one another, as you see here with the human figures in the foreground. The reason you should not be concerned is because you will trace over your pencil lines with your pen, let the ink dry, and then erase all of the carbon on the drawing, resulting in a very crisp black and white drawing full of detail.

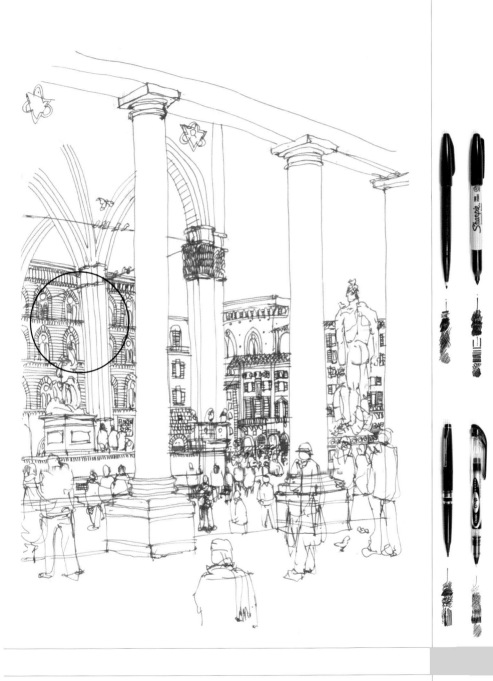

The roller-ball pen, with waterproof ink, helps you add a lot of detail to your drawing, and those details capture visual elements to communicate the "sense of place".

Notice how the human figures enable you to communicate both an urban setting and a level change in a city.

Later in Chapter 3, *Methods*, perspective drawing, looking up, and looking down will be demonstrated.

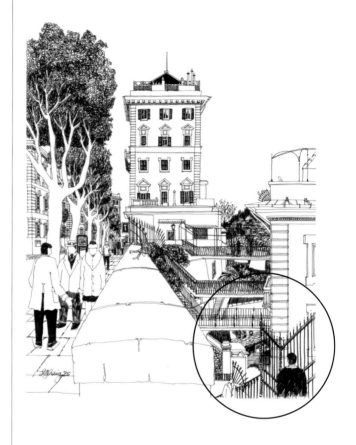

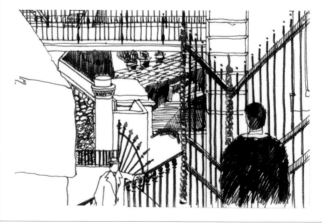

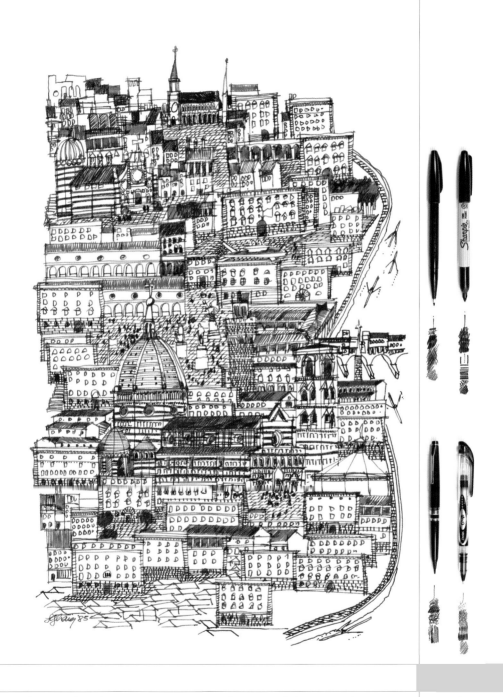

I learned this perspective method by studying ancient chinese drawings. Give it a try.

A good, fresh black roller-ball pen allows you to make continuous, rapid strokes, without the line quality breaking down or skipping. Take a look at the brickwork in these drawings. The horizontal brick coursing is fairly accurate, but what makes the brick read are the alternating vertical mortar joints. These are carried out throughout the drawing on each wall surface. It takes time, but the end result gives mass and substance to the wall.

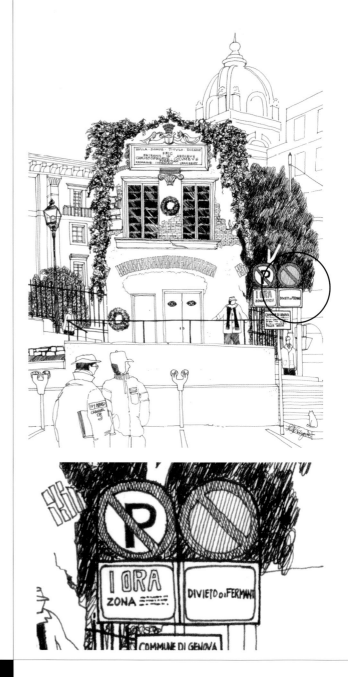

look for the cats in these drawings!

If you want fine detail in your black and white drawings, then the black roller-ball pen should be your tool of choice.

These drawings were first drawn in pencil, redrawn over using the roller-ball pen, and then the carbon was erased, giving a clean, crisp urban image full of detail.

These two drawings were first quickly sketched in pencil. Then, the black roller-ball pen was laid on its side, producing a broken line of varying widths as the ink came out of the point. The technique of holding the pen on its side gives an antiquated look to the drawing that captures the marble of the obelisk and surrounding buildings.

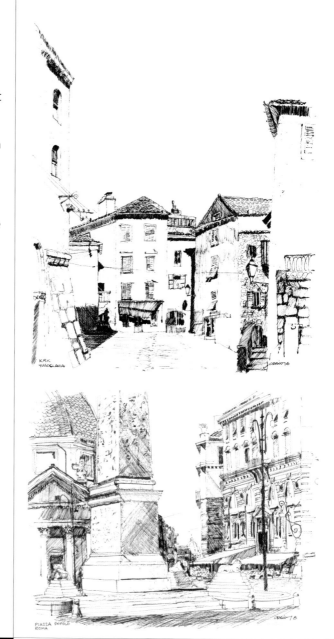

Piazzo Popvlo in Rome, Italy

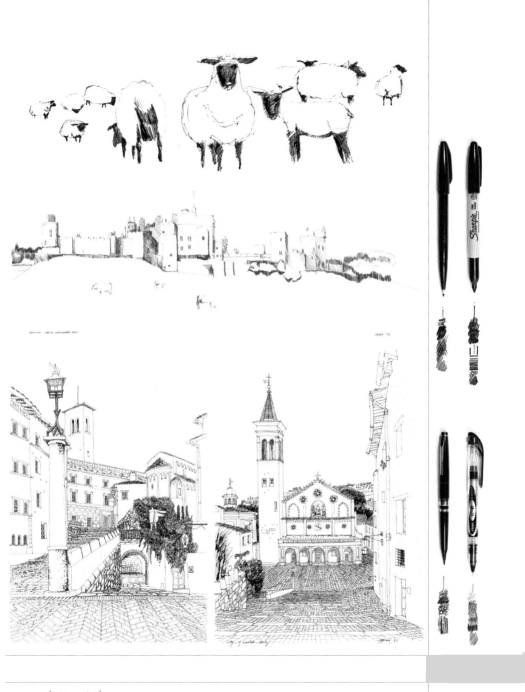

A helpful hint when sketching preliminary drawings on-site is to first take a photograph of your view, then do a draft sketch, then later, back in your hotel room or studio, make a final drawing.

The difference between a sketch and a drawing is the amount of time and detail you can put into your illustration.

We use the words CONTEXT and ENTOURAGE when visually capturing the space in-between buildings, such as floorscapes, trees, tables, roofscapes, and human activity.

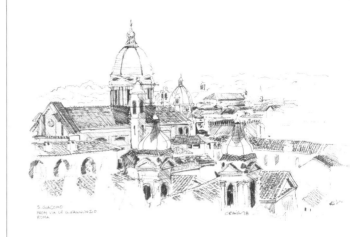

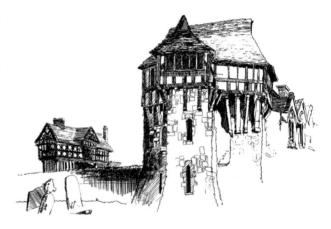

This sketch shows a Gaudi building in Barcelona, made with a black roller-ball pen, to illustrate the streetscape view of the buildings.

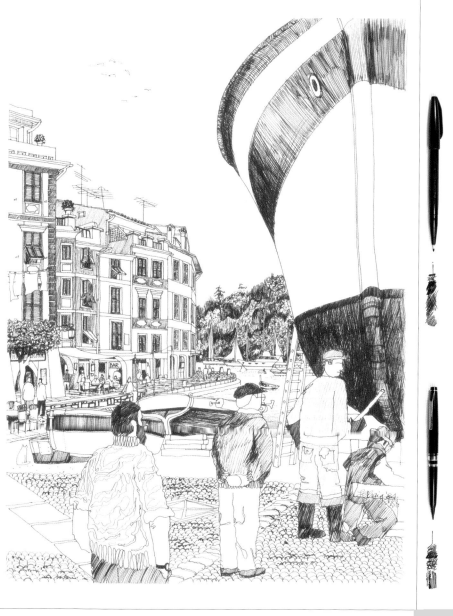

This drawing was made on large bristol weight paper,
which is why so much detail was possible. The men
working on the fishing boat make the drawing come alive.

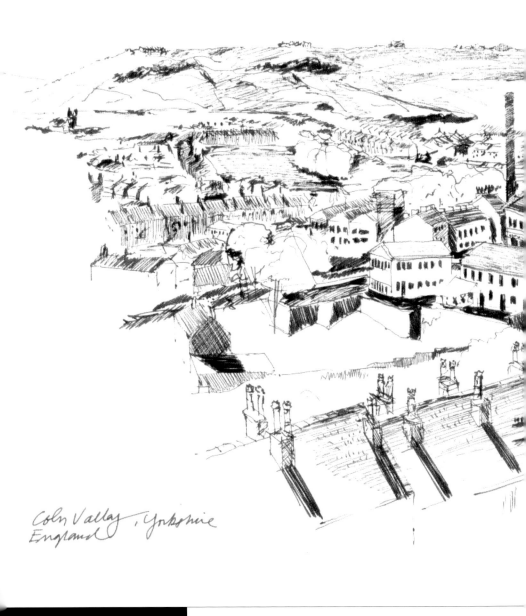

Coln Valley, Yorkshire
England

looking down on existing towns will enable you to achieve
a better perspective of your aerial drawings.

Specific regional landscapes can be drawn using the pen, as shown in this illustration. All three of the perspective visual depth components are shown: foreground, middle ground, and background.

Take a look at the technique of drawing the shrubs and trees in the foreground as random, squiggly lines. Sufficient lines are drawn to give black depth and mass to the foliage. Now, notice the huge live oak tree in the middle ground and see that the trunk is left "white", with a mass of leaves creating the form. The ground plane is purposefully drawn with a horizontal line to make sure the horizon is locked in from edge to edge of the paper.

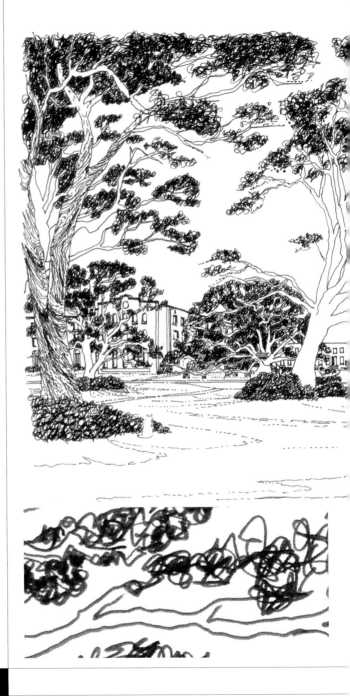

These are drawings of a university campus on the Gulf Coast.

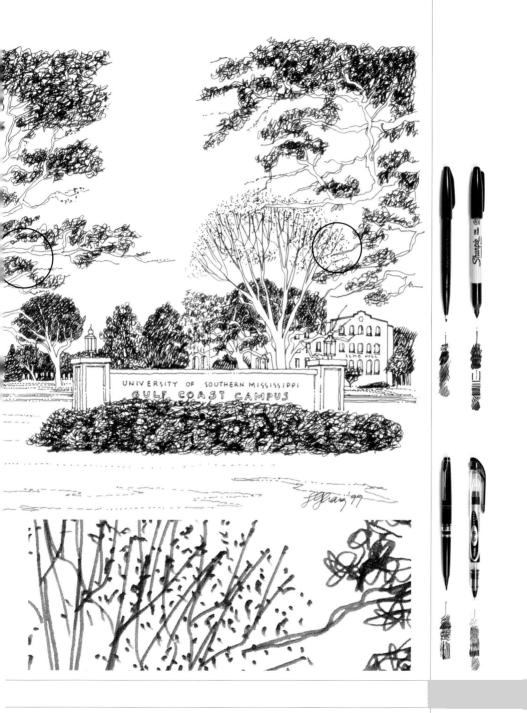

Notice how live oak trees "hunker down" and hold their ground!

Practice drawing these techniques with your pen. Notice the angular depth of the images, where planes of dark line work are contrasted with lighter areas. Remember that capturing sunlight on the earth and building surfaces will enable your drawing to have more depth and impact.

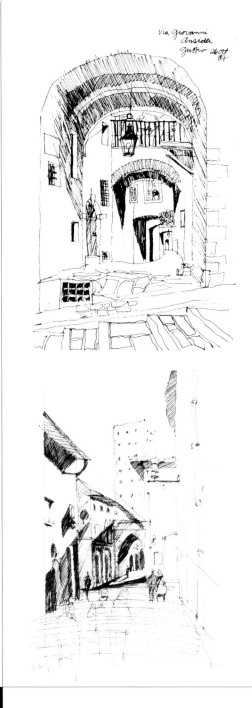

Drawing rock escarpments with clustered seaside vernacular buildings at the high point

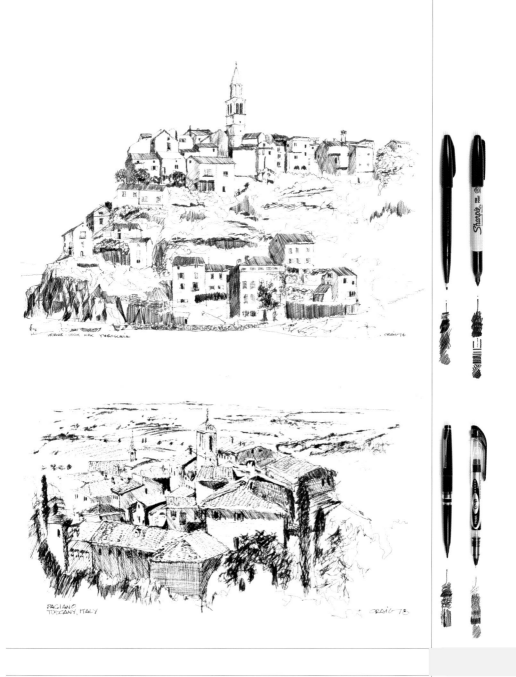

VRBNIK · OTOK KRK · YUGOSLAVIA. CRAIG '74

PACIANO
TUSCANY, ITALY CRAIG '78

or ancient castle fortifications can become regular daily
activities as you travel internationally.

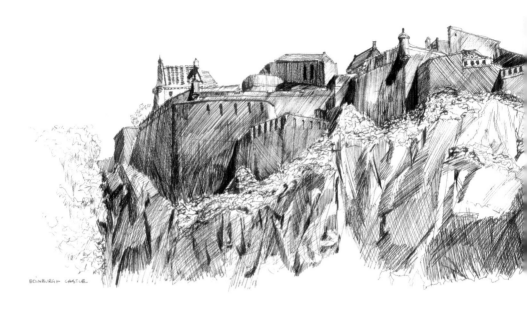

EDINBURGH CASTLE.

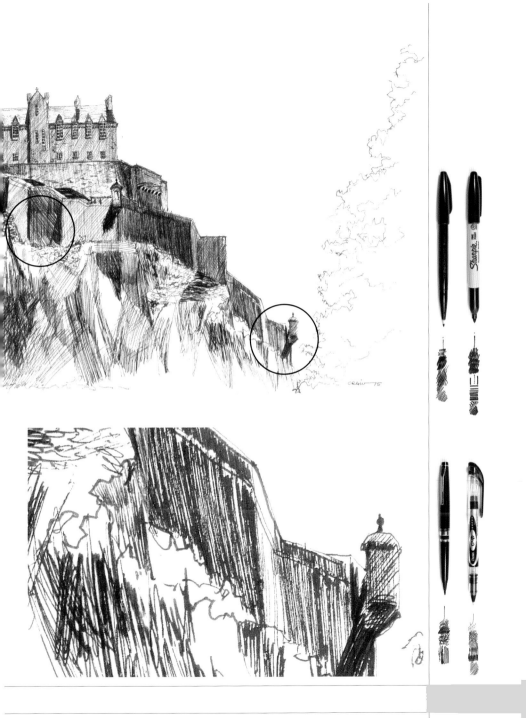

A large drawing requires two sheets of paper. Never let the size of a drawing be limited to the size of the paper!

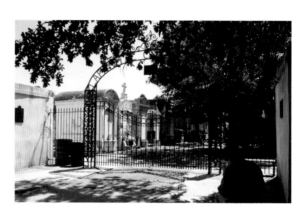

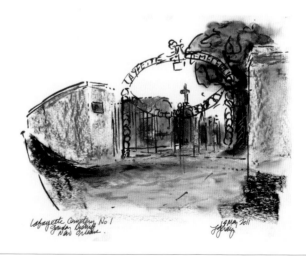

Lafayette Cemetery, No 1
Garden District
New Orleans.

14 May 2011
Lfray

Find a spot, unfold your stool, get your tools out, and just draw. Keep date stamps on your photos for later reference.

Color

Moving from black and white images, we now introduce the use
of color tools as a method of expanding your visual thinking and
drawing techniques. Although there are almost endless varieties of
color drawing tools available to you, this chapter will focus on just
a few of these tools as they are intended to be readily available to
you during your site visits and travels.

The color tools illustrated are soft pastel, oil pastel (and black brush
pen), Prismacolor pencil, crayon, ChartPak markers, and watercolor.

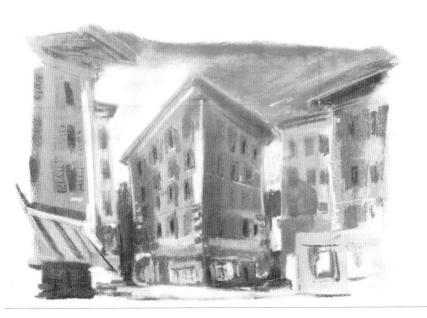

soft pastel

When we think of pastel drawings, it is usually "soft images" that come to mind, created by laying down pastel and blending color to render the desired image. The pastel tool comes in a variety of shapes, sizes, and colors. Some are even made into "pastel sticks", much like colored pencils.

This is a drawing tool which you will come to enjoy using, especially in a controlled studio environment. The reason this location is suggested is because soft pastel is generally pretty messy. When you apply the chalk-like medium to your paper it creates a lot of dust residue, which drops to your lap if you hold your paper vertically while you draw. It is not the best tool to use for site sketching. However, it is a very strong color tool to use in a studio setting.

Pastel sticks and rough pastel paper create soft images of a place.

A close look at the surface of the paper will reveal how the highly textured surface creates highlights in the brown tone of the drawing.

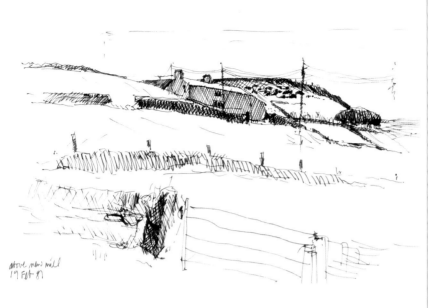

above new mill
19 Feb 89

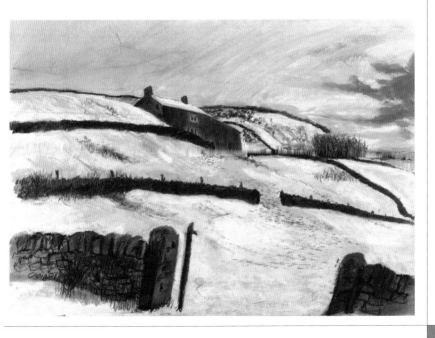

site sketches can later be used to assist you in making a
final drawing.

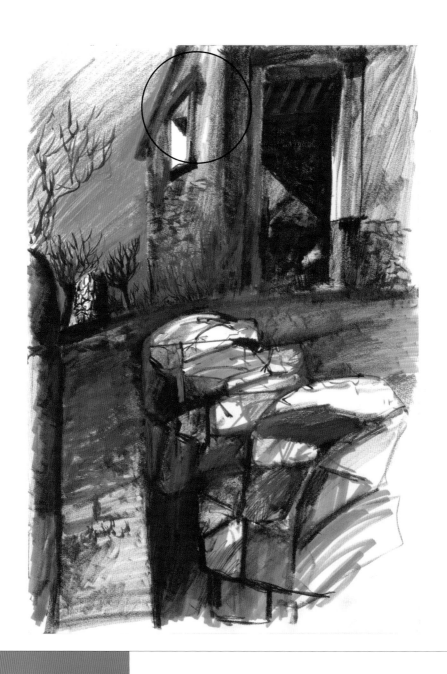

paper surfaces are referred to as having "tooth". Slick surfaces, like mylar film and

Prismacolor pencil and sticks

Blending mediums is perfectly acceptable, as long as the tools that you are using go well together and are harmonious in appearance.

This vernacular building on a hillside near Genova, Italy, was drawn using mellow earth tones, developed by blending Prismacolor pencils, ChartPak markers, and soft pastel sticks.

Notice the detailed image below, where the rough surface of the watercolor paper gives the building the look of stucco.

pristol, are smooth. Rough paper, like watercolor paper, has the most tooth.

When using Prismacolor pencils, it is suggested that while you are drawing, keep your hand strokes going in the same direction, ideally in sloped, diagonal lines. Avoid cross-hatching, as this will make your images confusing to read. This is an important technique to remember to use.

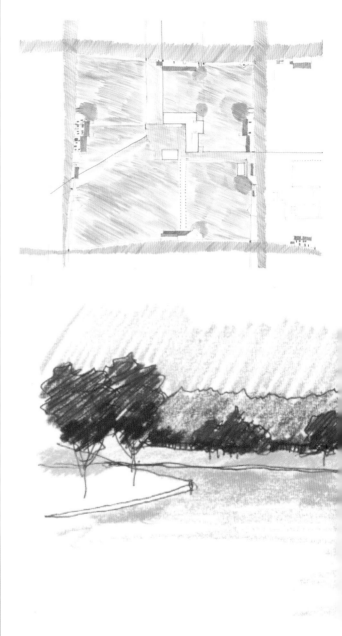

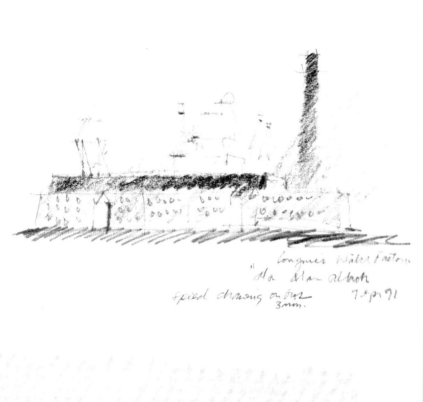

Longmeir Water Faction
" da Alan Attack
Speed drawing on bus 7 apr 91
 3mm.

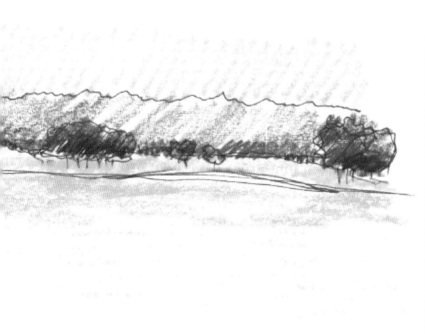

Keep Prismacolor strokes going in one direction — either
right-handed or left-handed — not both!

Your Prismacolor sketches and drawings can be developed to have rich color content and visual impact by overlaying similar colors. Use three shades of blue for your sky. Similarly, use several shades of green blended with yellow ochre and aqua for the grass.

This stained glass Gothic window was first drawn with a black roller-ball pen, then Prismacolor pencils were used to capture the daylight passing through the glass.

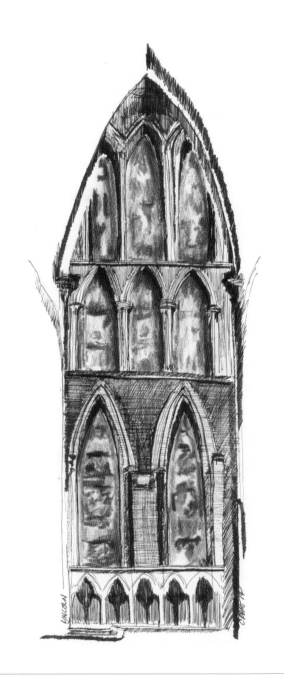

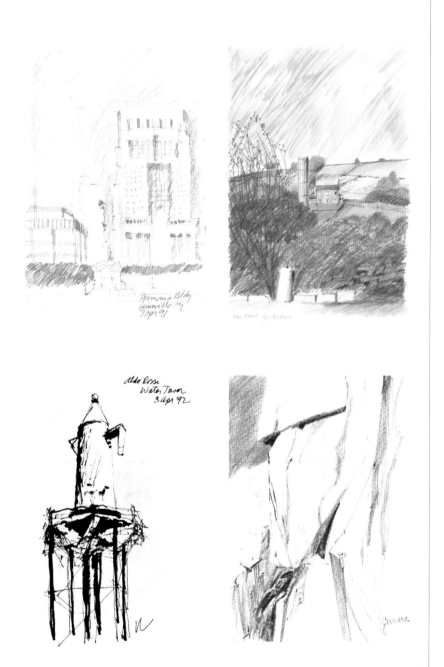

Earth's form and rock forms offer organic sketches...

The two urban sketches illustrated here are examples of blending Prismacolor pencil and roller-ball pen.

The annotated landscape sketches are drawn using Prismacolor sticks, which have the same color range as Prismacolor pencils. Here, the blue, green, and yellow sticks are laid on their sides and dragged across a roller-ball pen sketch.

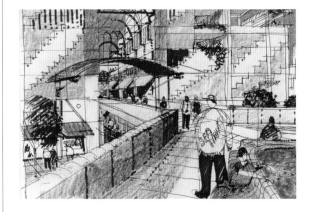

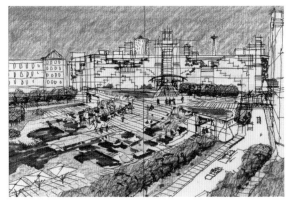

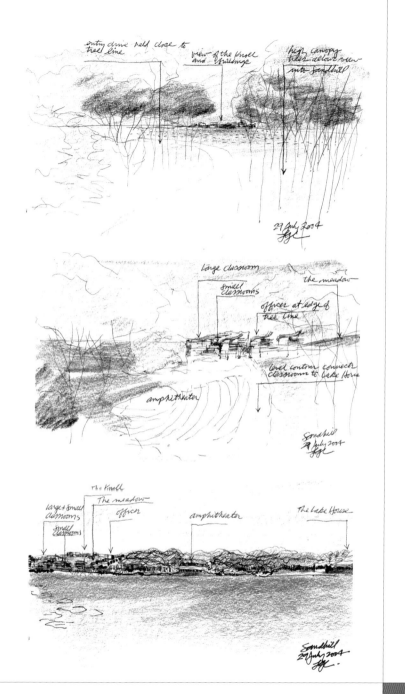

entry drive held close to
tree line

view of the knoll
and buildings

high canopy
trees below view
into Sandhill

29 July 2004
SFS

Large classroom

Small
classrooms

the meadow

offices at edge of
tree line

level contour connects
classroom to Lake House

amphitheater

Sandhill
29 July 2004
SFS

The Knoll

The meadow
offices

Large + Small
classrooms

Small
classrooms

amphitheater

The Lake House

Sandhill
29 July 2004
SFS.

The oil pastel sketches and drawings lend themselves to a creative use of color and texture in your work. The first thing you may notice when you open the oil pastel box is its familiar scent as the aroma is distinctly similar to crayons.

Unwrap the paper jacket surrounding the oil pastel stick. This will free you up to not only use the point of the tool, but also to drag color across the page.

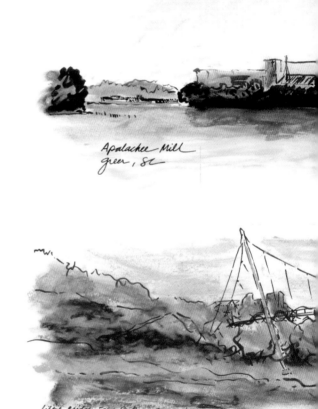

Apalachee Mill
green, SC

Liberty Bridge, Falls Park Greenville, SC

oil pastel and brush pen

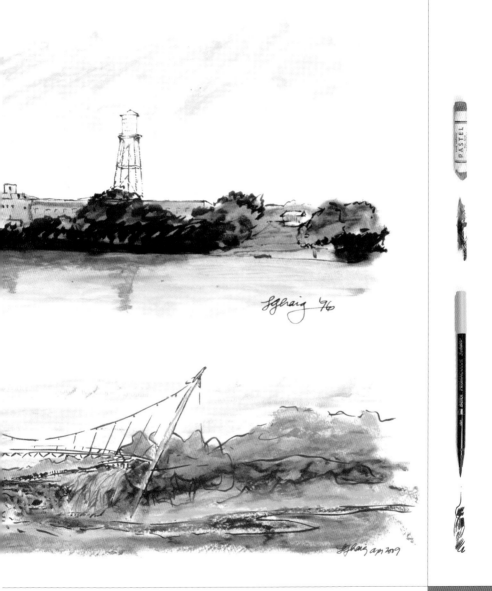

Sghaig '16

Sghaig apr 2019

fingers get dirty with oil pastel all over them... memories of childhood...

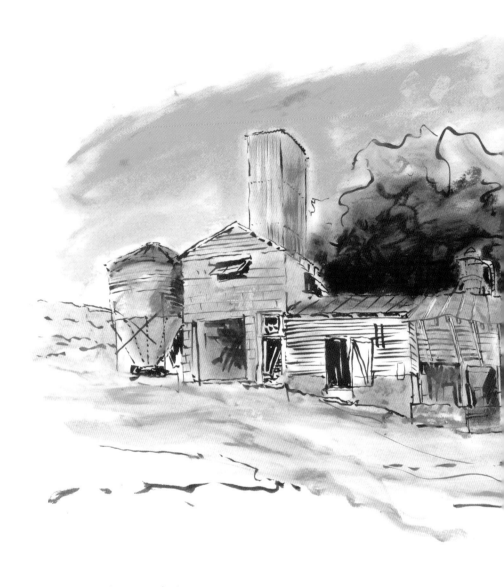

Suber Mill
greer, SC.

vernacular architecture is fun to draw,
especially when it has been built over time.

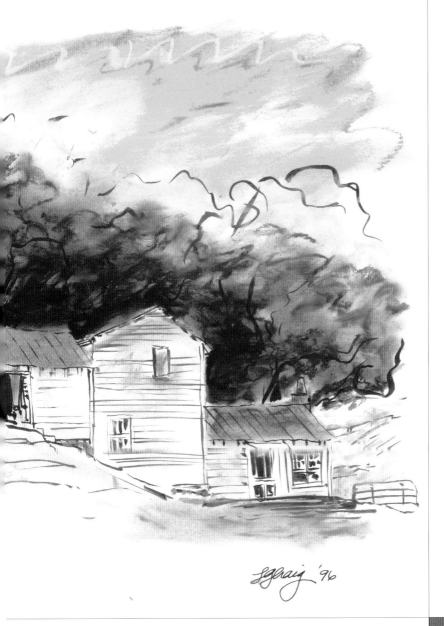

sgraig '96

The oil pastel sketches and drawings illustrated throughout this book are first drawn using a black brush pen. This is available at most art supply sources as an economic, non-refillable pen. If the pen is going to be in regular use and becomes a core tool in your drawing bag, it is recommended to purchase a cartridge brush pen, as well as a pen with a fine sable brush point.

The beauty of oil pastels is that they come in a range of boxed sets, containing as few as twelve colors in a beginner set to high-quality sets of fifty. A suggested range to start with is the twenty-four set by CRAY-PAS.

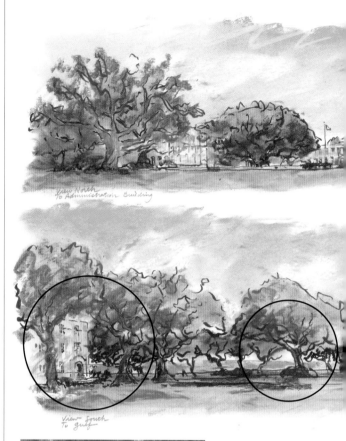

View North
To Administration Building

View South
To grass

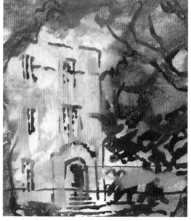

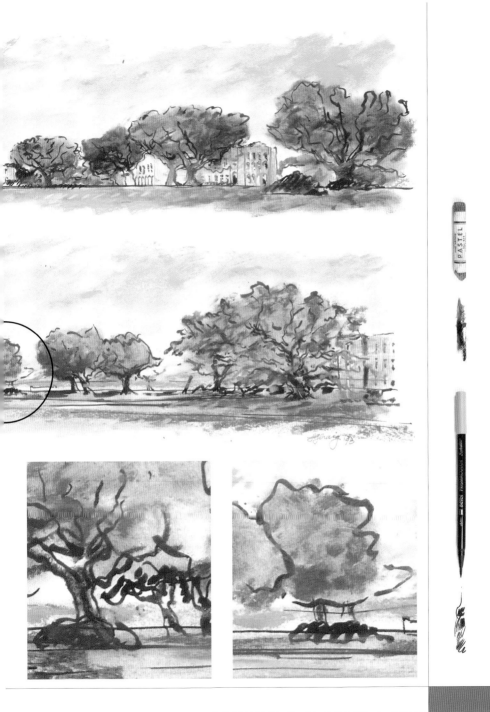

live oak trees have sloping trunks...

Applying oil pastel is very similar to the techniques learned when using Prismacolor pencils, in that you want to become comfortable overlaying oil pastel colors on top of each other. Then, with your fingers, push the colors around and blend them. But be careful not to muddy the drawing by obscuring the true colors into a dark mess.

Notice the blending of colors in each of these oil pastel drawings, and how the brush pen still reads through them.

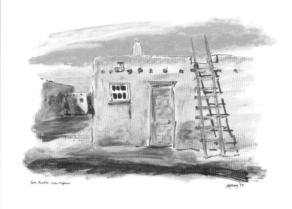

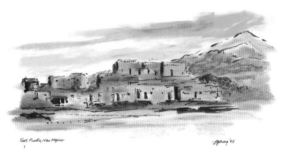

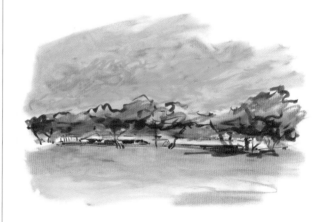

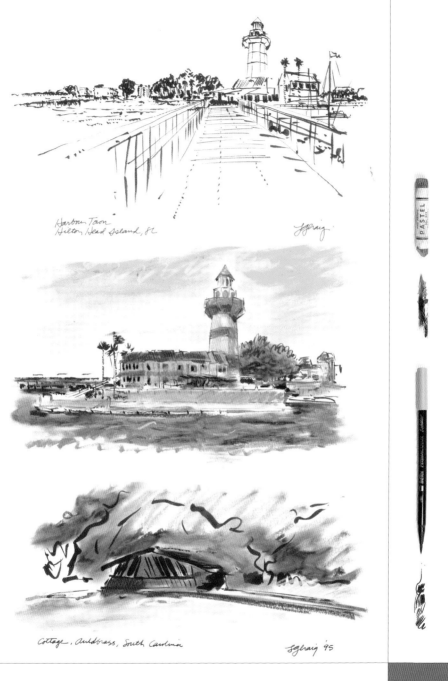

Harbour Town
Hilton Head Island, SC

sgcraig

Cottage, Auldbrass, South Carolina

sgcraig '95

The brush pen gives visual line variety, narrow to broad.

These oil pastel drawings of a university campus required two full sheets of Bristol weight paper butt-jointed together, to allow for a full panoramic view.

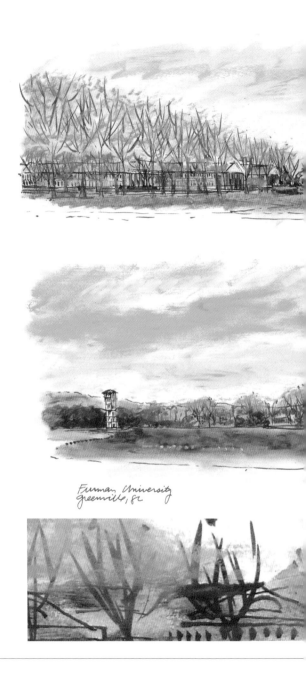

Furman University
Greenville, SC

The trees were drawn without leaves by flicking the brush pen very lightly in an upward hand stroke. Try this a few times on a plain sheet of paper. One stroke down for the trunk, several quick strokes up for the branches.

You learn a lot about building and spatial design by drawing university campuses.

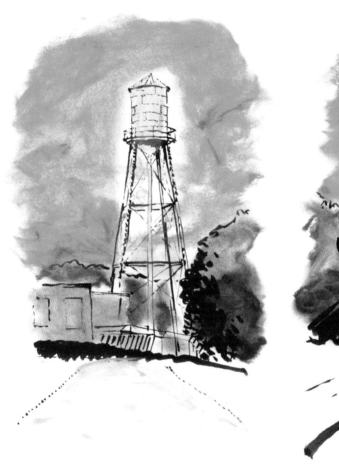

Apalachee Mill

Victor M

Water Towers,

Draw them before they disappear!

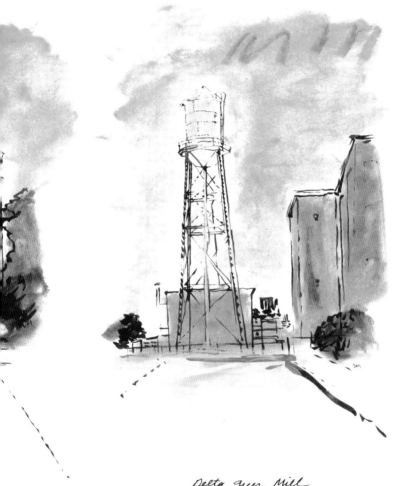

Delta Queen Mill

S9Craig '96

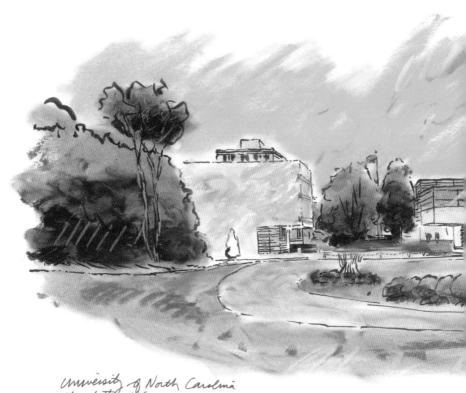

University of North Carolina
Charlotte, NC

New campus plans offer you new buildings
to draw...

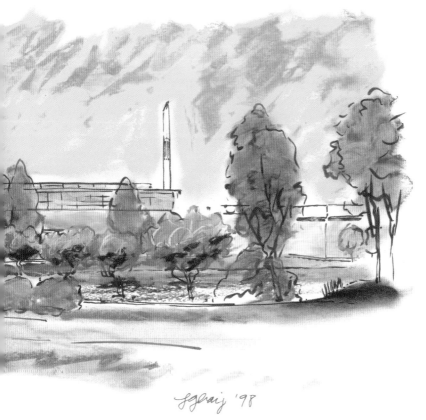

egleaig '98

Drawing night views can be achieved by using dark blue and dark purple oil pastels. The use of light yellow and white pastels can capture interior spaces. Grab hold of your white Prismacolor pencil and hit your night sky with quick, small dots to create stars.

Regional landscapes can be drawn by selecting oil pastel colors of the place you are drawing: desert earth tones, olive greens for wet swamp areas, and bright yellow and blue for coastal beach scenes.

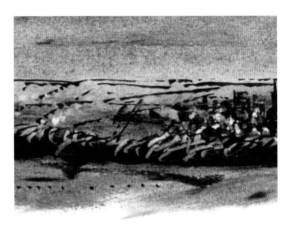

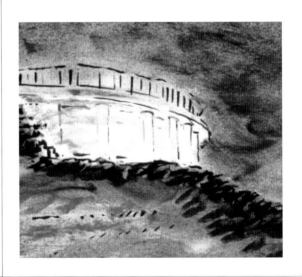

Nothing quite like drawing night scenes!

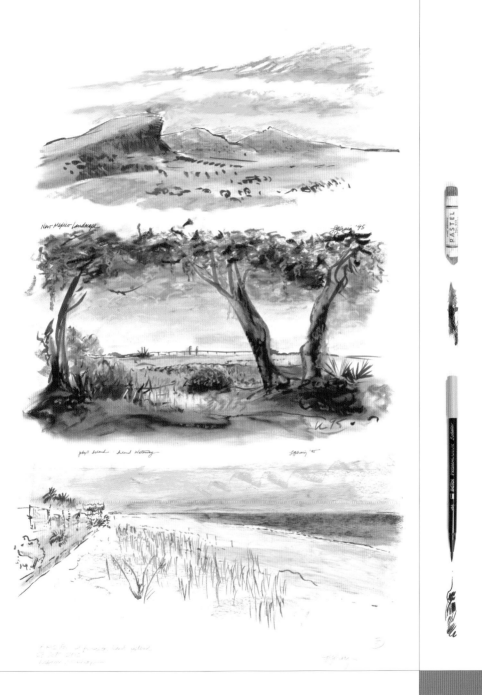

New Mexico Landscape

JGrey '95

Jekyll Island — Island Waterway

JGrey '95

A dynamic urban sky can help communicate the location, time, and season of your drawing. The active blue sky with a hint of white clouds conveys a mountain region, while the orange sky to the west in the urban perspective lends itself to the time of the day.

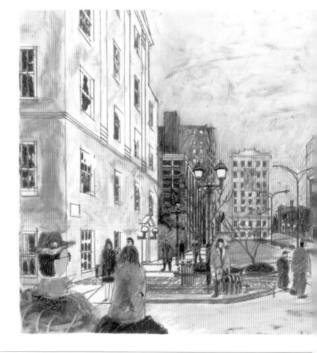

Drawing public places during your travels can improve your townscape design proposals.

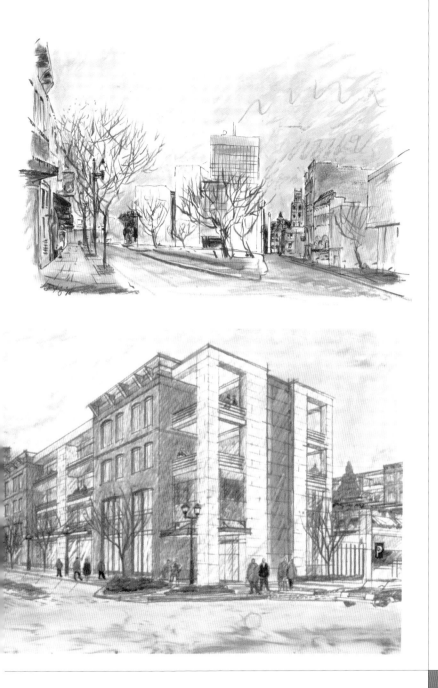

Blending oil pastel colors on top of a brush pen sketch with very limited amount of detail gives an overall impression of the PLACE of this drawing – New Orleans and the Mississippi River.

Take a close look at how the windows are drawn in the mid-rise buildings. These are just simple black strokes, almost a little hit-or-miss. The intent of using the brush pen is that you do not have to draw everything. Get the form and shape down, then let the oil pastel complete the drawing.

Drawing water is not always blue, but sometimes a blend of sepia, terra cotta, and olive green, with some strokes of cream.

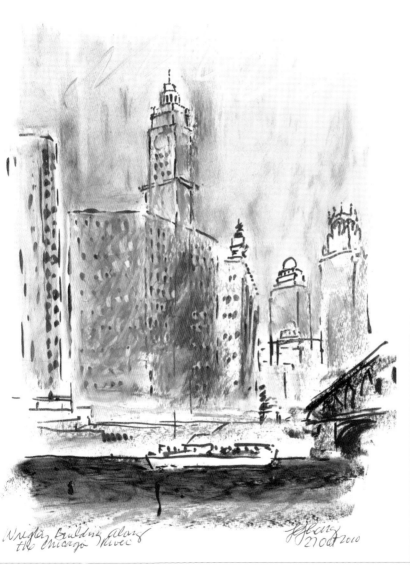

Wrigley Building along the Chicago River
27 Oct 2010

Dragging the oil pastel stick on its side gives simple,
immediate surface texture to your sketches and drawings.

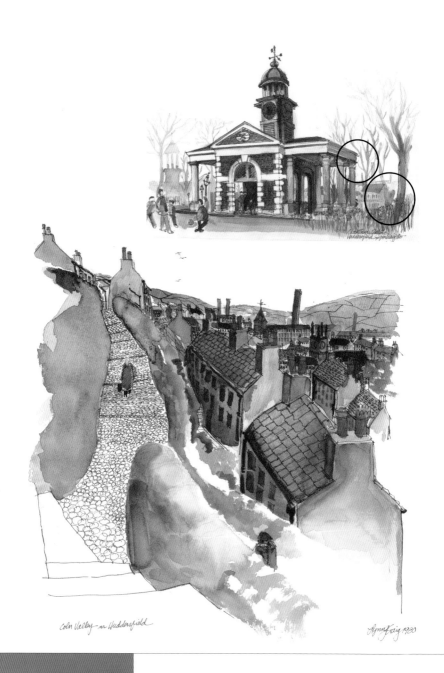

Coln Valley nr Huddersfield

Lynn Faig 1930

watercolor

Sketching and drawing with watercolor is one of the more difficult techniques to be mastered, for watercolor images are intended to be transparent and full of light. As with any on-site sketching technique, it can fill in an already-drawn pencil or waterproof pen illustration. Two basic rules to follow are: keep the images transparent, not muddied, and give the drawing time to dry so additional color layers can be added.

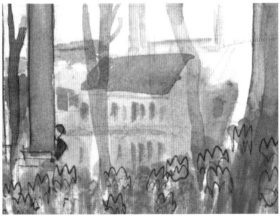

Watercolor is about capturing transparency.

Learn watercolor techniques by experimenting with different types of brushes, observing how water moves across paper of different weights. Do these experiments while not actually trying to do a site sketch, as this learning method will allow you to concentrate on the technique, not the subject.

Good quality, economical face and eye brushes can be obtained from your local drug store. They are small, give good brush strokes, and come in a variety of sizes.

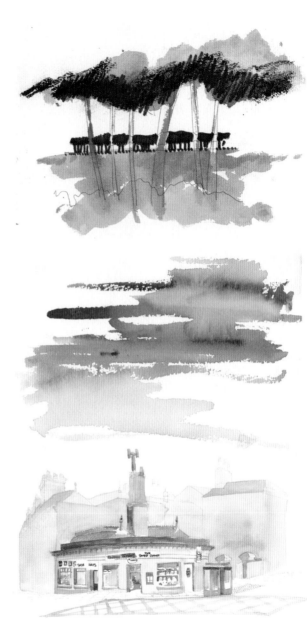

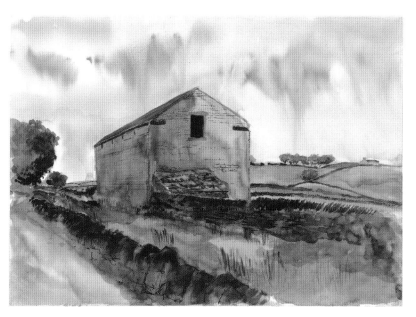

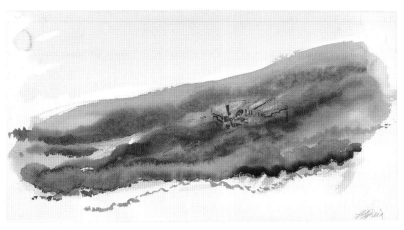

watercoloring is difficult, but you must experiment with the tool. It offers great possibilities!

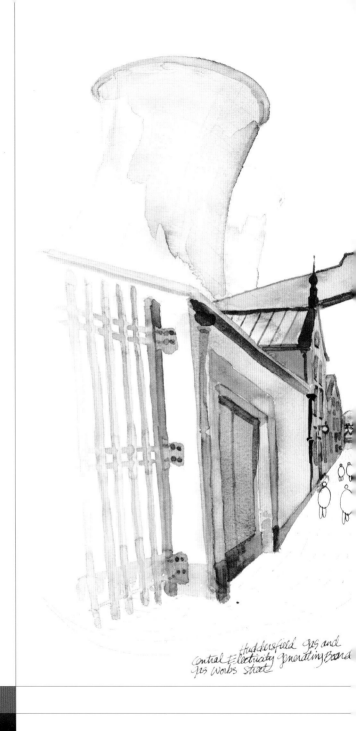

Huddersfield Gas and
Central Electricity Generating Board
Gas Works Street

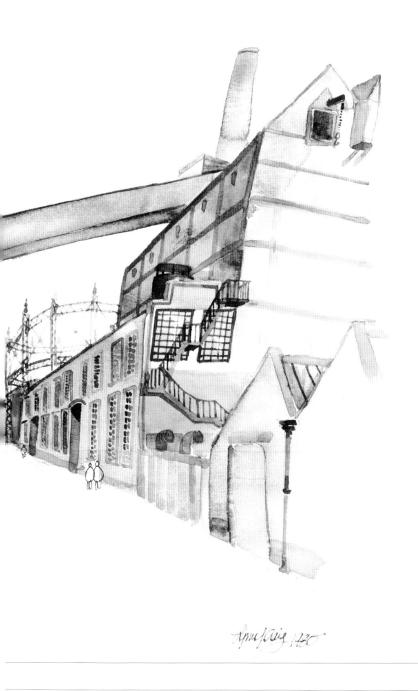

Exaggerated perspective can capture the height and mass of the place you are drawing...

Small and large rolls of white and yellow trace paper (referred to as trash) take all drawing mediums, but respond especially well to color markers and Pentel Sign Pens.

High-grade vellum is excellent for ink work.

Plastic mylar film is the most durable drawing material, and it allows you to erase everything. Mylar film takes carbon pencils, Prismacolor pencils, and oil pastels the best.

A small, pocket-size sketch book with a ring binder allows the paper to lay flat, and allows the image to cross over both pages.

A large, 14"x17" Bristol drawing pad with an adhesive binder is best for studio work. Sketches can be removed from the pad, laid end to end, and butt-jointed together providing space for a large drawing that extends over two sheets.

paper Types
+ Drawing Equipment

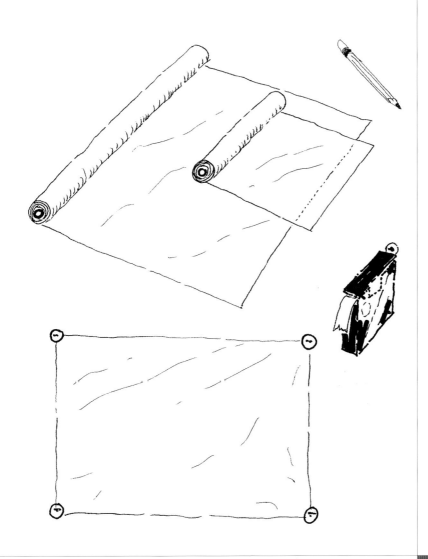

Always packed in your shoulder bag should be your camera, iPhone, compact digital camera, extra batteries, and chargers. Larger digital cameras are more difficult for "quick draw" shots, but they give you many more format and resolution possibilities.

A small, portable, light-weight folding chair, with a canvas seat and back, will provide comfort and free up your knees to rest your drawing pad on. Find a chair that folds up quickly and is carried on your shoulder, so you can keep your hands free. Your chair should have large, rubber tips on its feet to avoid slipping and sinking into the ground.

A good-sized shoulder bag to carry all of your drawing tools gives you quick access to its compartments, unlike a backpack. The bag should be strong and durable, to give you many years of service. It should be cleaned regularly to keep it in good shape.

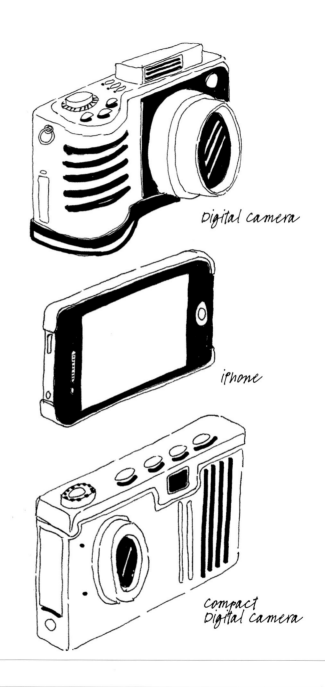

Digital camera

iPhone

Compact
Digital camera

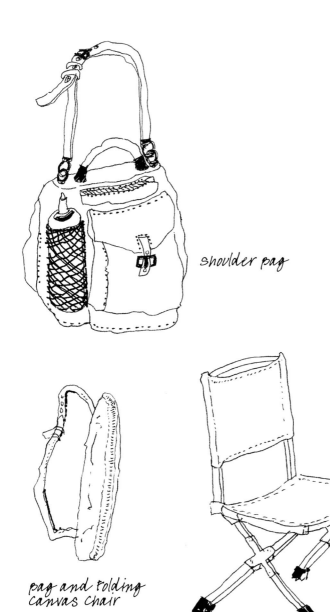

shoulder bag

bag and folding
canvas chair

A small pocket knife is very handy to have in your bag, for sharpening pencils or scraping the oil pastel off of your drawings.

Store all of your completed drawings in a lightweight portfolio case. This will keep them flat and protected.

eraser

portfolio case

pocket knife

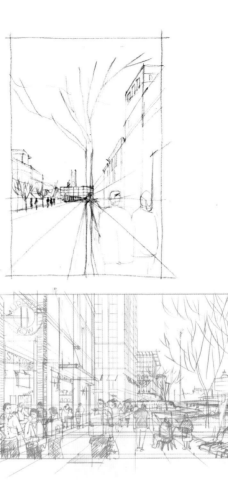

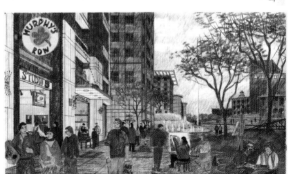

From sketch pad to trace to final mylar...

3. Methods

Drawing Rules

Yes, there are a few rules you must follow in order for your drawings to have a degree of realism and visual strength.

Rule One: Horizontals are Horizontal

Your horizontal lines must be horizontal and parallel with the earth's horizon line. The horizon line is always at eye level, no matter where you are on the earth.

Rule Two: Verticals are Vertical

This is an absolute must in the setting-out of your drawings. Keep building facades, flag poles, and lamp posts plumb and vertical.

Rule Three: One Vanishing Point

Vanishing lines are the only lines which are sloping, and they all go to a single point. The classic "railroad tracks disappearing in the distance" is your reference.

1. Take three sheets of 8 1/2"x11" white paper. One of these will become your FRAME OF REFERENCE for your sketch.

2. With a pair of scissors, cut three 1" circles into the sheets of paper. Do this by folding the paper and cutting out a semicircle along the crease. Cut one circle at the top of a sheet, one circle at the middle, and one circle at the bottom of a sheet.

3. You will now have 3 sheets of paper with 3 holes cut at the top, middle, and bottom.

4. Ring the hole in a red circle using a Sharpie fine point marker. Then draw a horizontal line through the hole, edge to edge. This line will relate to the HORIZON LINE.

Looking Down, Looking Straight Ahead, Looking Up

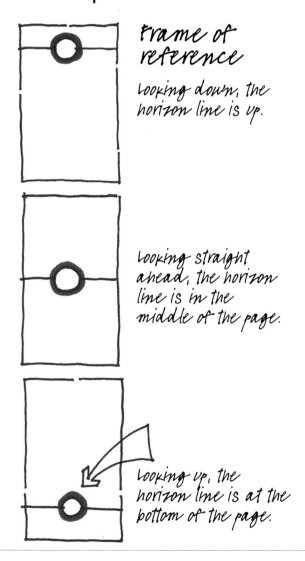

Frame of reference

Looking down, the horizon line is up.

Looking straight ahead, the horizon line is in the middle of the page.

Looking up, the horizon line is at the bottom of the page.

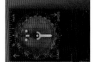

one-point perspective exercise

This example uses a vertical sheet, but you can use a horizontal sheet as well.

Top hole

Middle hole

bottom hole

Drawing Rules for a one-point perspective sketch

Rule one: Horizontals are Horizontal

Your EYE is always on the HORIZON LINE, no matter where you are, on top of Mount Everest or at street level on Michigan Avenue in Chicago.

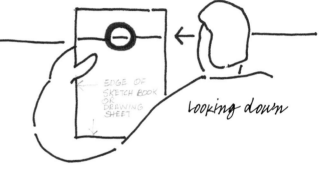

EDGE OF SKETCH BOOK OR DRAWING SHEET

looking down

Horizontal lines must be horizontal and parallel to one another.

Rule Two: verticals are vertical

Vertical lines must be vertical and parallel to one another.

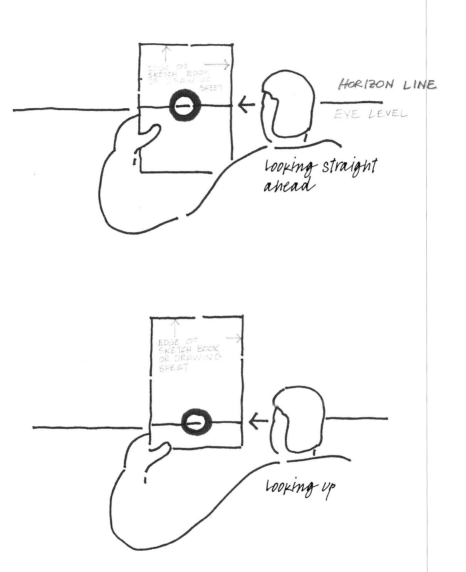

EDGE OF SKETCH BOOK OR DRAWING SHEET

HORIZON LINE

EYE LEVEL

Looking straight ahead

EDGE OF SKETCH BOOK OR DRAWING SHEET

Looking up

We now have covered the overall idea of setting up the one-point perspective sketch. The following is how you begin your sketch.

1. Frame of Reference

The frame of reference is drawn on the sketch book page, either in portrait (vertical) or landscape (horizontal) format. This rectangular box is just a starting reference for your sketch view that you will draw. You can adjust the frame of reference during your sketch; you can go outside of the lines, it's okay.

2. Horizon Line

We have learned that the horizon line is always at head height. If we want to look straight ahead, the horizon line is drawn across the middle of the page. If we want to look up, the horizon line shifts to the bottom of the page, so we have more area to draw at the top of the page. If we want to look down, the horizon line goes across the top of the page, so we have more area at the bottom of the page.

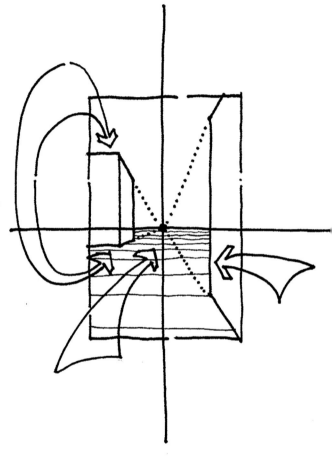

3. One Vanishing Point

We learned that only three lines construct the one-point perspective: the vertical line crosses the horizontal line, and these join the diagonal vanishing point line.

These basic lessons are illustrated in the following diagrams.

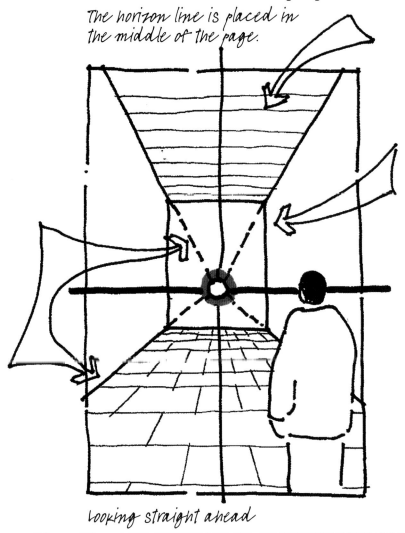

The horizon line is placed in the middle of the page.

Looking straight ahead

Rule Three: one vanishing point

With only one vanishing point, all planes in perspective will vanish to one point.

The horizon line is placed at the bottom of the page.

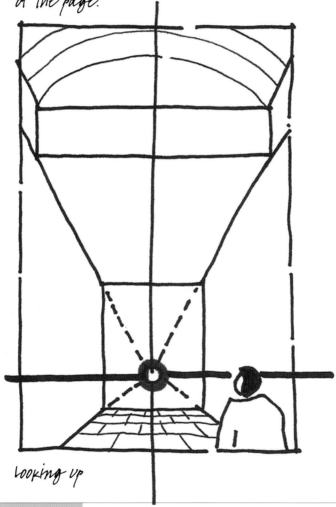

looking up

The horizon line is placed at the top of the page.

looking down

The horizon line is always at eye level. Use human figures in your drawing to help set up the horizon line, then add your vanishing point.

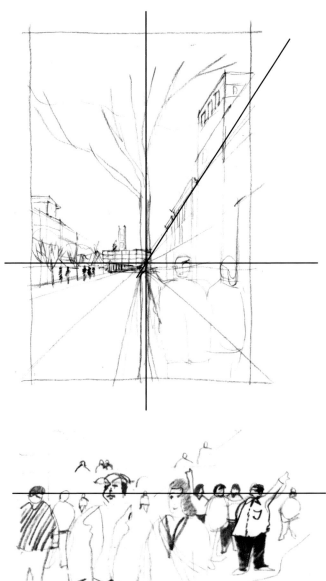

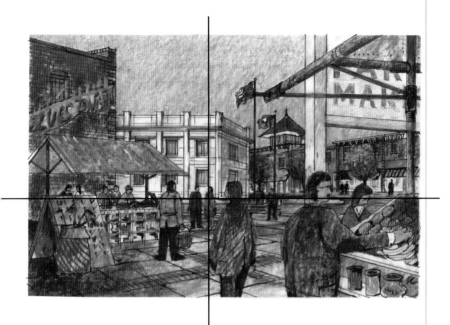

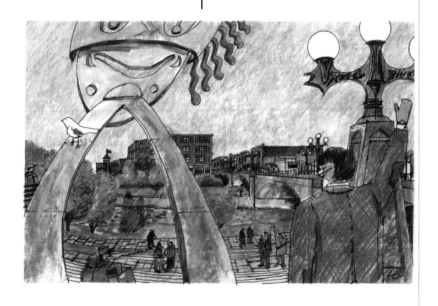

Adding people to your drawings gives a sense of depth and visual activity.

The first draft sketch is your visualization of the place you want to communicate. The buildings, the space in-between the buildings, and the people occupying your scene should be roughly sketched out. The sketch wants to capture the essence of your ideas.

Black Prismacolor pencil was first used to outline these images, followed by the primary colors of the buildings and landscapes.

A dark purple sky gives the impression of activity in the evening.

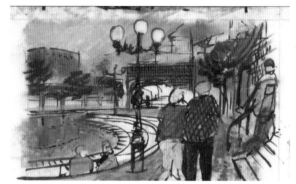

Draft sketch on trace.

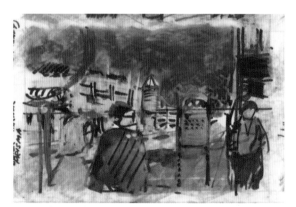

Draft sketch on trace.

process: Developing the sketch into a final Drawing

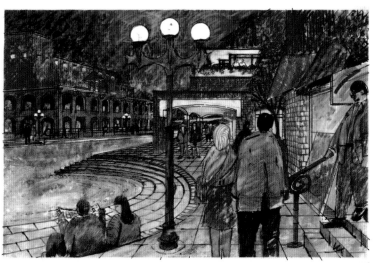

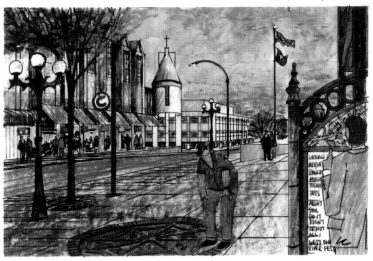

The first drawings combine straightedge India ink lines, as well as freehand lines, to give an impression of the place you are creating. Color is added using Prismacolor pencils, oil pastel, and black brush pen.

Even a friendly cat enters the drawing at the bottom left!

Start your drawing on sketch trace paper. Overlay the initial sketch with another sheet of trace and gradually build up your drawing by adding detail. A final drawing is best done on mylar film, as it is very durable and color can be added or erased easily.

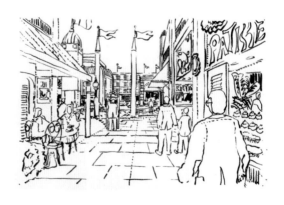

It's a step-by-step process...

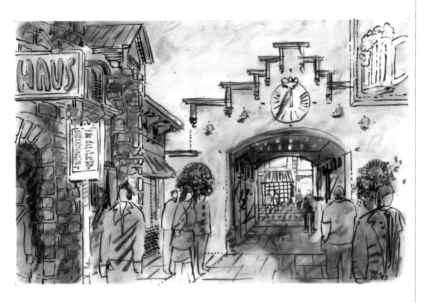

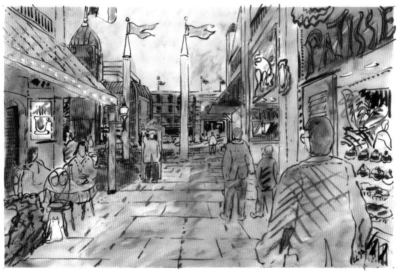

Those chocolate éclairs are making me hungry as I draw them!

Creating depth in your drawings is achieved by addressing three specific visual depths.

We call these depths:
Foreground,
Middle Ground, and
Background.

Foreground visual depth is directly in front of you, and has considerably detailed information in the drawing.

Middle Ground depth is something like twenty to fifty feet away, where some detail is shown.

Background depth is limited to the outlines of shapes, forms, and profiles of objects in the drawing.

Get all three of these visual depths in your drawing, and you will be able to capture the sense of place of your subject at any scale.

foreground

creating Depth:
foreground,
Middle Ground,
background

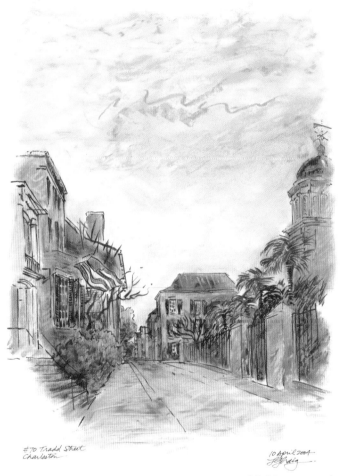

#70 Tradd Street
Charleston

10 April 2004
LeCraig

Middle Ground

Charles Demuth 1883 – 1935
. And the Home of the Brave 1931
Lancaster, Penn.

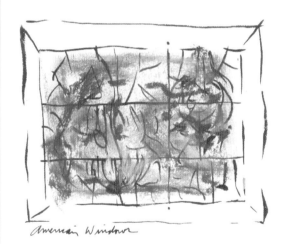

American Window

[1] [2] [3]
3rd pane.

Marc Chagall
Chicago
20 Apr. 2002

The drawing examples shown are from sketch
book studies of artwork in the Art Institute of

learning from the masters

An age-old method of learning drawing technique is positioning yourself in front of an artwork you admire and drawing that artwork as a facsimile of the original. This method of "learning from the masters" goes back to the early development days of a young intern joining the master in his studio and learning first-hand the tools, techniques, and methods of that craft, be it painting, sculpture, or architecture.

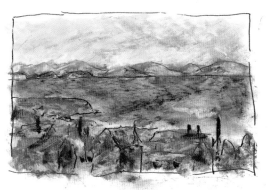

Paul Cézanne 1839-1906
The Bay of Marseilles, seen from
L'Estaque c. 1885

art Institute,
Chicago 1 Oct 2011
Sgbaug

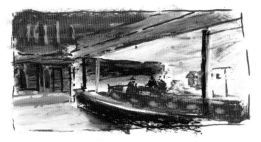

Edward Hopper (1882-1967) Nighthawks, 1942 Oil on canvas
art Institute, Chicago
28 Oct 2010
Research Study by Sgbaug

Chicago. These sketches of artwork are drawn directly in
a small, pocket-size sketch book.

By looking at a painting intently for an extended period of time, you will learn color theory and composition from the original artist. By selecting a wide range of drawing subjects and locations, you will develop your inventory of memorable places. You will begin to see what they saw through your own eyes. This method of learning color theory, composition, and technique is a challenge at first, but after repeated sessions, your skills will improve greatly.

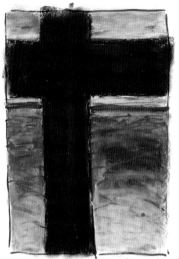

georgia O'Keefe (1887-1906) Black Cross, New Mexico 1929
oil on canvas, one of a series of cross paintings that georgia O'Keefe
produced in her first summer in the Southwest, in 1929.
"I saw the crosses so often.... like a thin dark veil of the
Catholic church spread over the New Mexico landscape... For me,
painting the crosses was a way of painting the country."
art Institute, Chicago research Study NY
28 Oct, 2010 SGCraig

Camille Pissarro
The Crystal Palace 1871

Claude Monet 1840-1926
Houses of Parliment, London
1900-01
Late afternoon at sunset from
terrace at Saint Thomas's Hospital

art Institute
Chicago
Jeffridy 1 Oct 2011

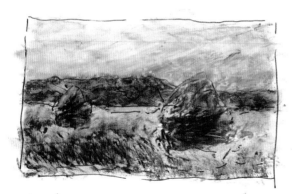

Claude Monet 1840-1926
Stacks of Wheat (End of Day Autumn)
1890-91

art Institute
Chicago, 1 Oct 2011
Jeffridy.

This drawing of Marc Chagall's "American Window" at the Art Institute of Chicago, drawn on-site, illustrates how you analyze an artwork as you draw it. You learn the artist's technique, and what might have been going on in the artist's mind during the composition and construction of the artwork.

The three-panel sketch with a scaled human figure is an outline of the full size of the window, with one panel blown up and studied in more detail.

panel 7

Marc Chagall 1887-1985
American Window 1975-1977

1 2 3

art institute
chicago. 1 ct 2011
gehry

Travel site sketches, completed quickly or fully rendered, and detailed drawings to be completed in the controlled setting of a studio, will provide you with an inventory of visual ingredients which make up "urban places" and "landform environments".

These two Genova, Italy, images were started as pencil drawings on large sheets from a Fabriano pad (12"x18"), which allowed a considerable amount of "urbanscape" information to be drawn. Upon returning to the studio, the pencil drawings were overdrawn with a roller-ball pen. When completed, all of the graphite was erased with a white plastic eraser by Staedtler. These drawings are called "duality drawings", as the location, Via Septembre, is first drawn from one side of the street and then from the opposite side, looking back at the position from where the first drawing was made.

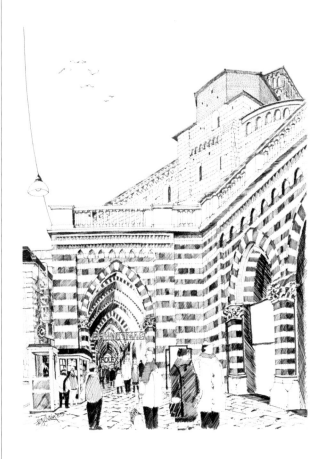

cityscapes + landscapes

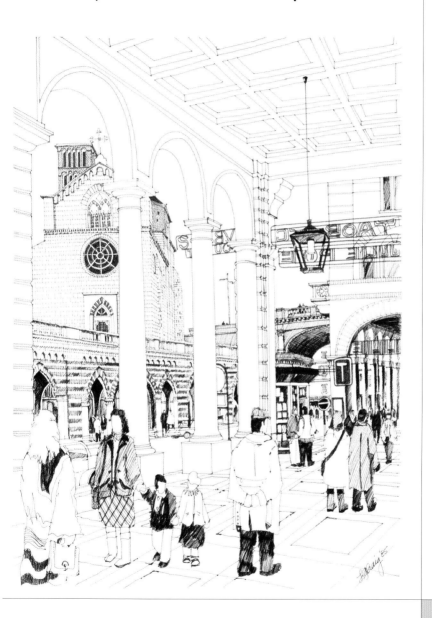

your cityscapes will come alive with the addition of people, cars, and building textures.

The cityscape and landscape drawings of Spoleto, Italy, use the same technique as the previous Genova drawings, but here the technique was to view the hill city from the east, and then from the west. The city castle gives you a landmark to orient yourself in relation to the other drawing. Fabriano paper was butt-jointed to allow the drawing to extend over two large sheets. The pen drawing, due to its small point, allows considerable detail to be added. Never let the size of the paper you are using limit the size of the drawing. Just tear out another sheet and continue.

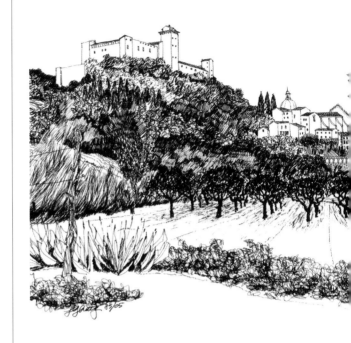

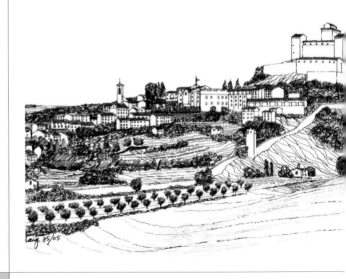

pig drawings, first in pencil on two sheets taped together...

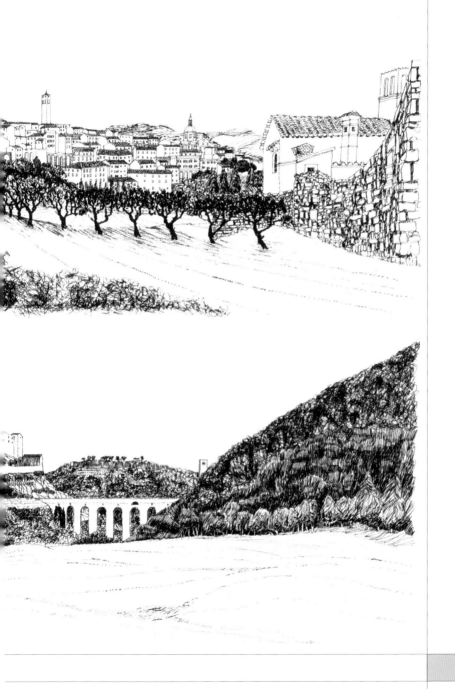

are later redrawn in roller-ball pen.

Faye Jones' Pinecote Pavilion at the Crosby Arboretum in Picayune, Mississippi, was drawn using the serial vision method developed by Gordon Cullen. The sequential drawings visually walk the viewer through the botanical garden paths, culminating at the shelter pavilion.

Sequential, or serial view drawings, are further explained in Chapter 4, *Drawing as a Way of Thinking*.

The soft oil pastels, which are smudged and blended by putting your fingers directly onto the drawing, capture landscape plants in the southern states, as well as the twilight at the end of the day.

Notice the power of the orange dot as an accent to the rope handrail.

A black brush pen, combined with oil pastels, can capture the mood and spirit of a place.

The beauty of the brush pen is that with a few, limited strokes, while the image is incomplete from a technical graphic standpoint, the lack of detail lets the viewer's eye complete the image. Then, by adding the oil pastel color, you can capture the particular visual essence of a place.

Look closely at the detail of the southern coastal drawing. The brush pen communicates foliage form, while the oil pastel picks up the ground plane and the live oak tree canopy.

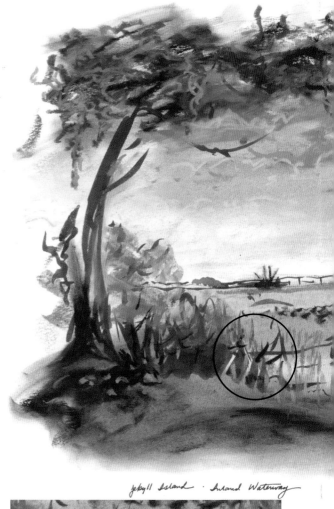

Jekyll Island · Inland Waterway

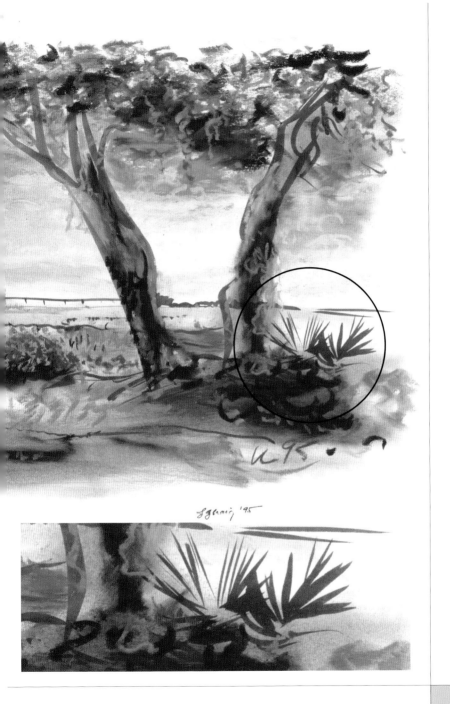

Don't overdraw your images... keep it simple! Let the tool do the work.

This drawing of the Penn Center on Saint Helena Island, Beaufort, was drawn using two sheets side-by-side. The stucco and wood clapboard-sided buildings are sited on sandy soil, with old, large live oak trees forming a landscaped canopy ceiling for the campus.

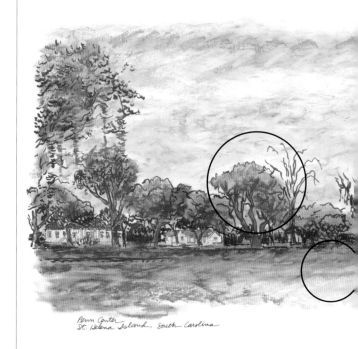

Penn Center
St. Helena Island, South Carolina

sunlight on the ground is a blend of yellows, sepia, olive green, and ochre.

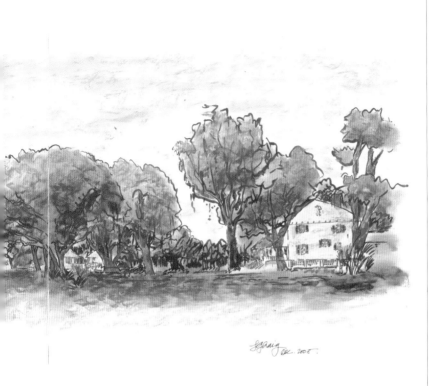

SJChaig Dec. 2008.

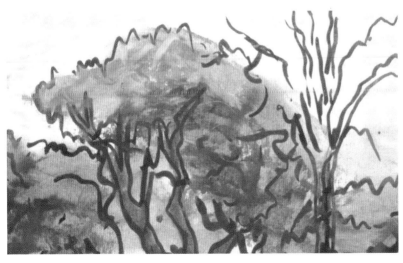

Adding people to your drawings makes the scenes come alive with action and scale.

You can take a life drawing class, but why? You are provided with so many everyday opportunities to sit back with your sketch book and observe the human figure.

Sitting in a concert hall with a conductor, musicians, and an audience will assist you in drawing a theatre design project. Drawing people in groups, standing, walking, or sitting can later be used in urban scenes.

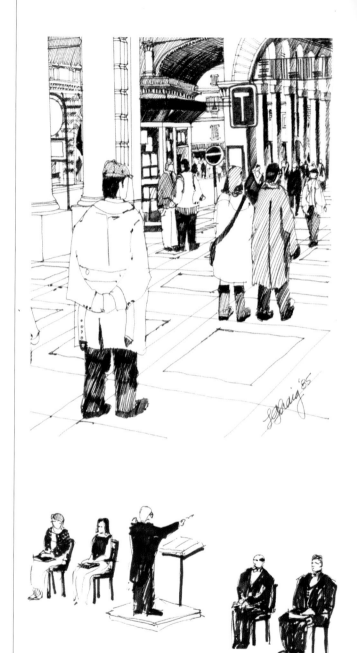

Drawing People

Your sketch book drawings made while travelling will include people in many different circumstances. This practice of drawing people will come in handy when designing proposals or presentations, and will help communicate how people will use your designs.

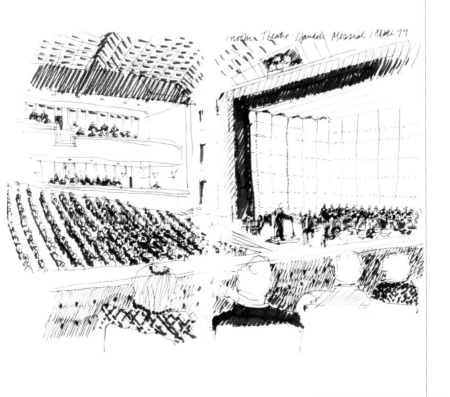

sketches and drawings come alive when people are added!

Next time you are in a restaurant, take a moment, pull out your soft sketch pencil, and observe how people interact with one another. The lesson here is that you must take additional time to both observe people's body language and to draw them.

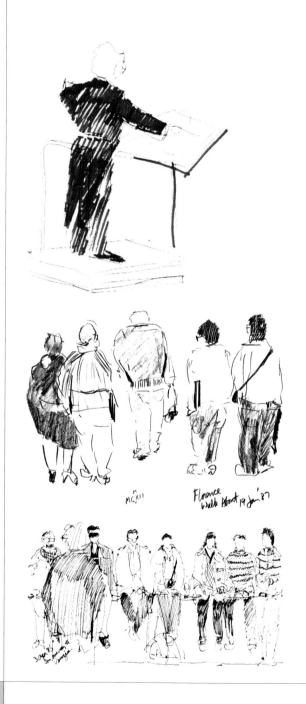

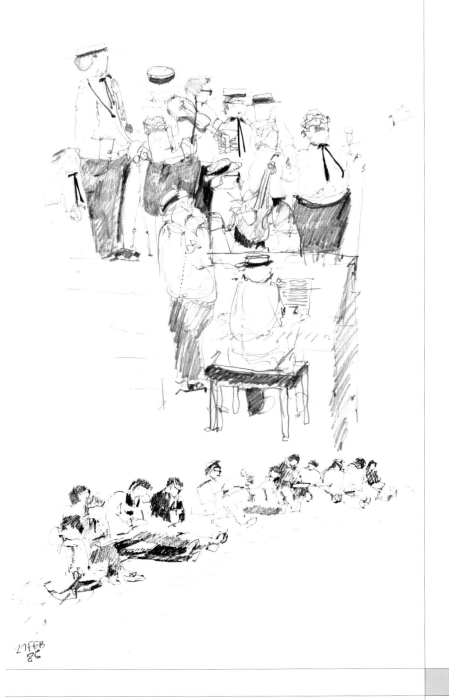

27FEB
86

quick pencil sketches can be drawn at any time and
any place!

First, draw three interlocking ovals, with the two lower ovals at about the same size. The top oval, which will become the head, should be smaller.

Do this exercise first in pencil, so that you can erase all of the lines you are about to make after you have drawn the final image in pen.

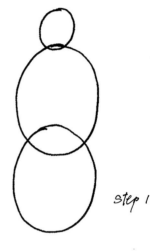

step 1

Second, draw four long ovals for arms and legs.

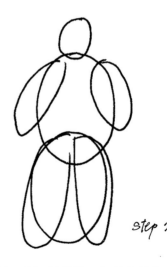

step 2

juggler

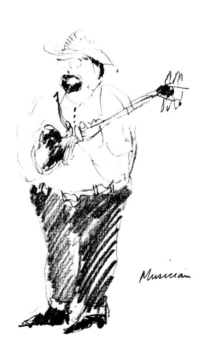

Musician

Third, give shape to the arms, hands, legs, shoes, and body. Draw a slightly curved line for the belt or jacket.

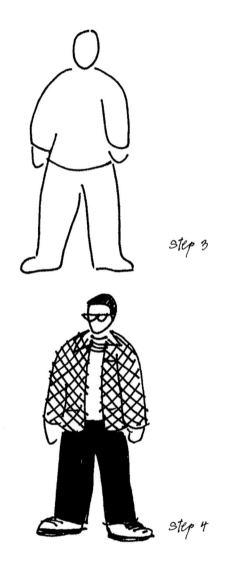

step 3

Finally, add a hair line and glasses. You can use the glasses and the angle of the head to direct the attention of the viewer to a particular area of the drawing.

Alternate white and dark areas of clothing.

step 4

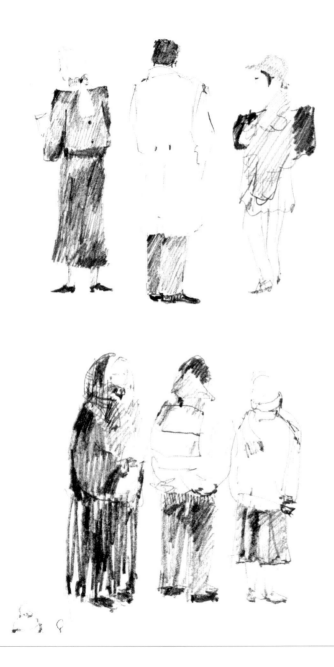

The people in
these images are of
different cultures and
nationalities. One
person is sitting,
waiting for a bus, while
the group of men
in an Italian café are
discussing the latest
sports news.

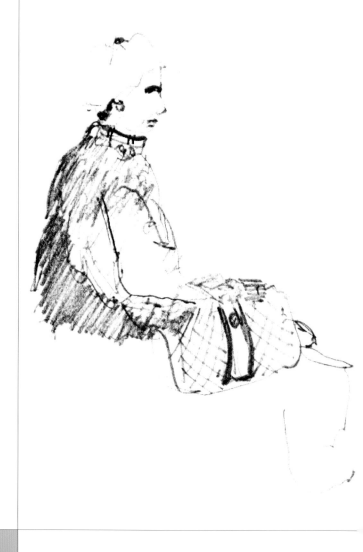

The best places to draw groups of people are in
restaurants, cafés and at festivals!

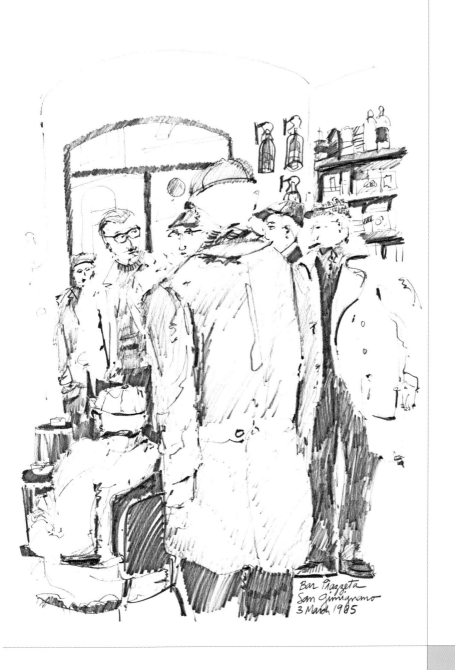

Bar Piazzeta
San Gimignano
3 March 1985

faces are hard to draw... check out the eyes of the men
wearing glasses.

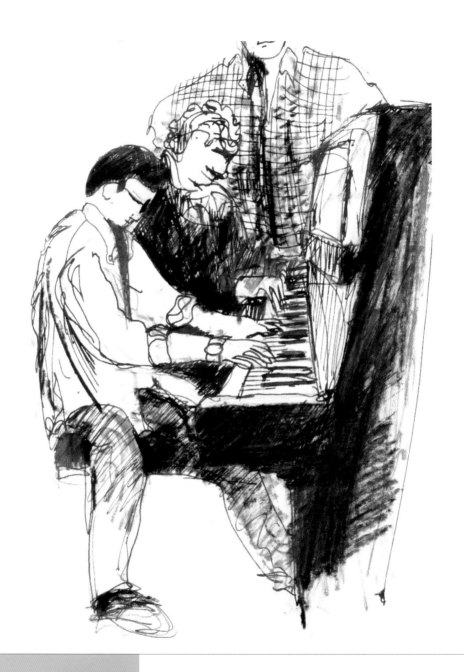

charcoal and roller-ball pen are quick, and produce a sketch with visual impact.

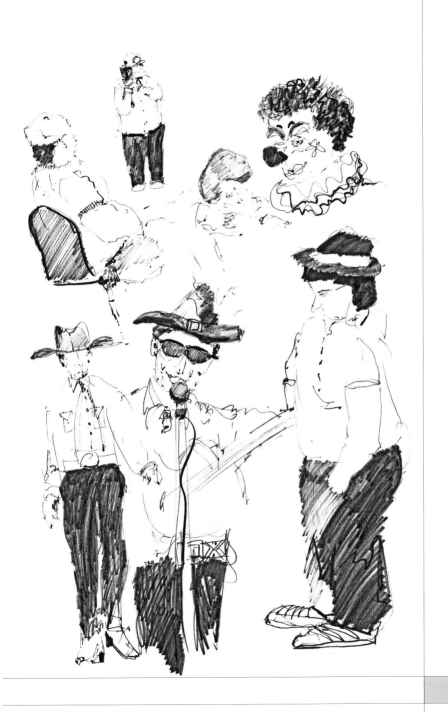

community fairs are good places to find
drawing subjects!

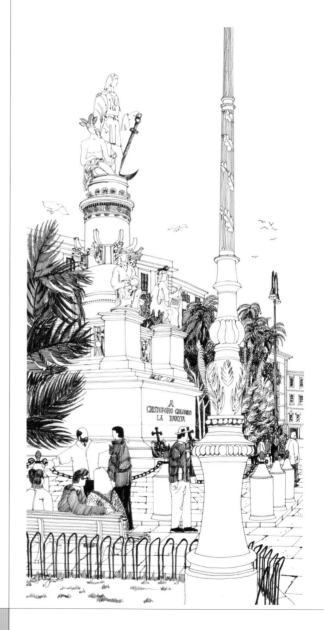

Adding motion to your human figures makes drawings come alive...

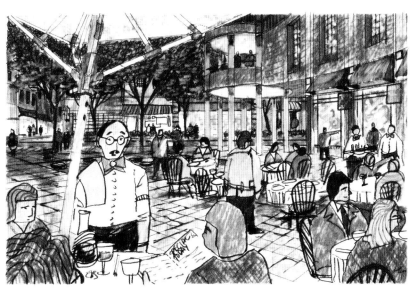

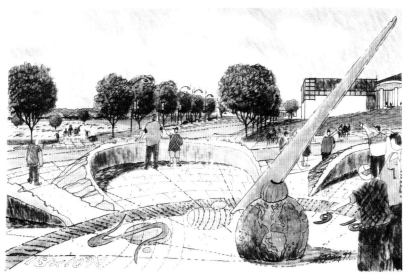

Drawing aerial perspectives follows the drawing rules set out earlier, but the main difference is that the horizon line is way above the top of your drawing sheet. What does remain as a rule is that the vertical lines are 90 degrees vertical. The major change is that your drawing becomes a two-point perspective, as opposed to having only one vanishing point. An easy way to start is to set it out as an axonometric drawing. This is illustrated in the aerial perspective of downtown Austin, Texas. A slight bending of the street lines toward an imaginary vanishing point to the top left gives an impression of dimension and distance.

The close-up view of the Austin street intersection follows the same principles as the aerial view of the urban intersection in Greenville, South Carolina.

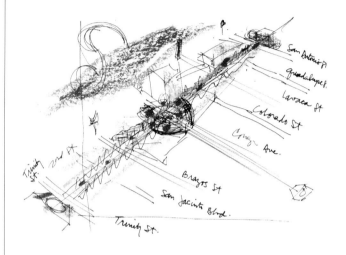

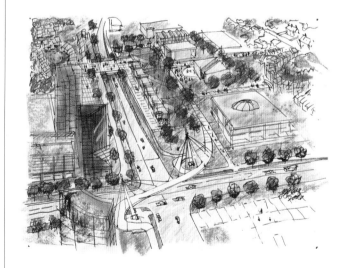

aerial perspectives

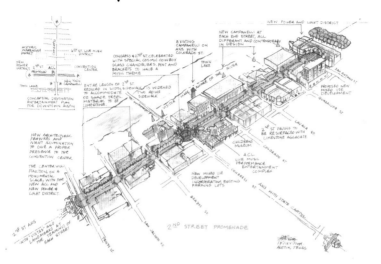

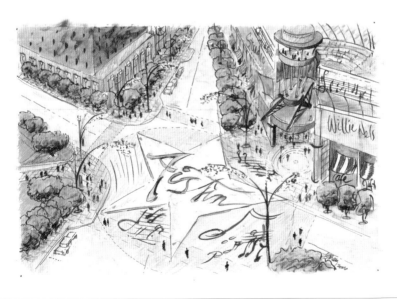

The street lights are drawn in red oil pastel and white-out typing liquid to provide impact.

You can choose to leave the drawing as an image or annotate the drawing with notes. The annotated method is recommended for short, focused notes to communicate additional information to the viewer.

These seven images show the development of a drawing from the first concept sketch to the final illustration, shown in two versions, one annotated, and the other without notes.

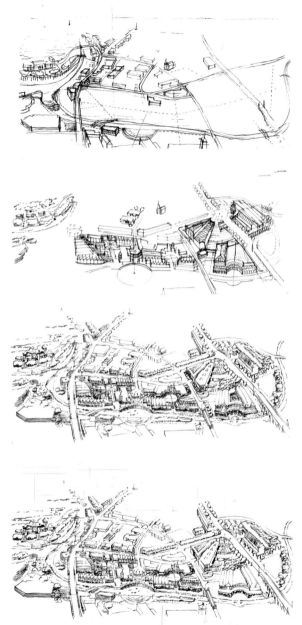

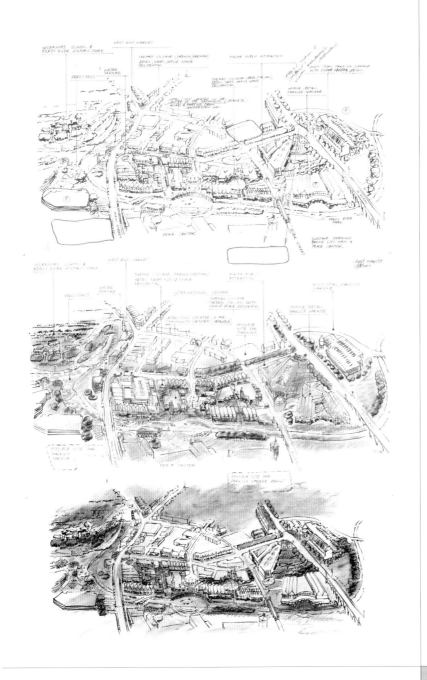

some drawings just take time to finish... it's a step-by-step process!

As demonstrated here, a "quick draw" is accomplished in a very short period of time, usually just a few minutes. The situations you may find yourself in might seem awkward, but you must take what is presented to you and record it in a sketch.

The boxed-framed drawings are a series of sequential pen sketches, drawn while walking in downtown Chicago.

Take advantage of time and the places you find yourself, such as looking out the window while you fly to your destination, or while you are waiting for your flight to take off at the terminal gate.

"Quick Draw": Limited Time

apt Tower @ St. Encl.

arcade

Bldg over street

L train passing between bldg.

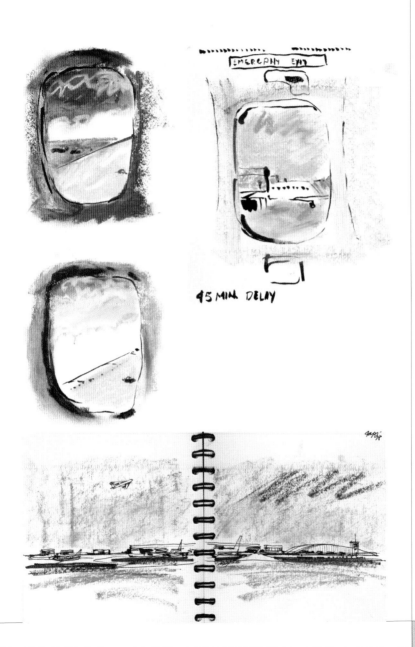

45 MIN DELAY

Take advantage of your idle time by drawing a
quick sketch!

"Quick draws" are done either while standing still and holding your sketch book or while walking. Sketching and walking at the same time is possible, as shown in the Sears Tower image, which is the same size as this book. Quick, simple lines and a splash of color will record the place for your memory and later reference.

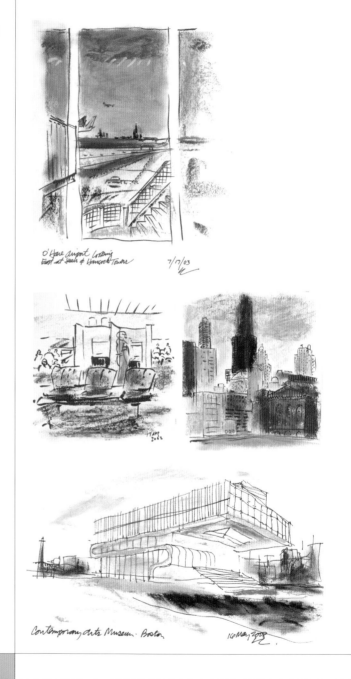

O'Hare airport looking East at South & Hancock Tower 7/17/03

Contemporary Arts Museum. Boston 16 May 2002

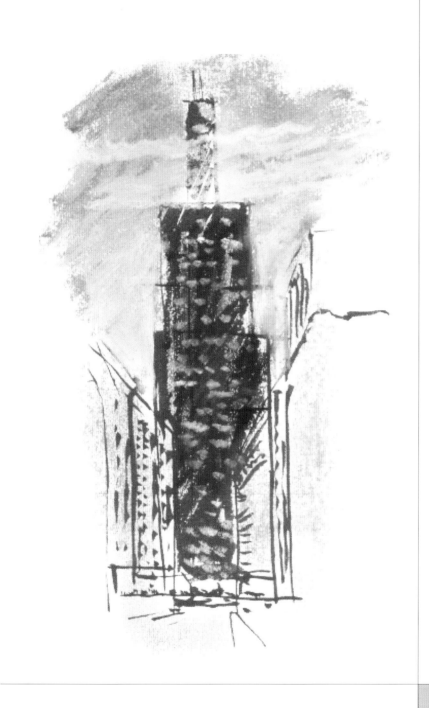

walking and sketching... better draw it now, because
you may not be back!

What is interesting about the "quick draw" is the power of capturing an image in a relatively short time period.

These images started with an outline in pen or pencil, with very little detail due to time constraints, then were filled in later with the use of color oil pastel. Notice the "quick draw" of Beacon Hill, Boston, where the brown stone windows are just color smudges, and the blue office glazing is drawn with a few horizontal lines. Dragging the oil pastel stick across the face of the building gives a reflective effect to the glass.

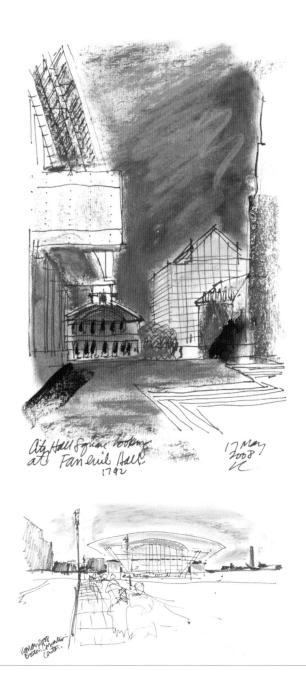

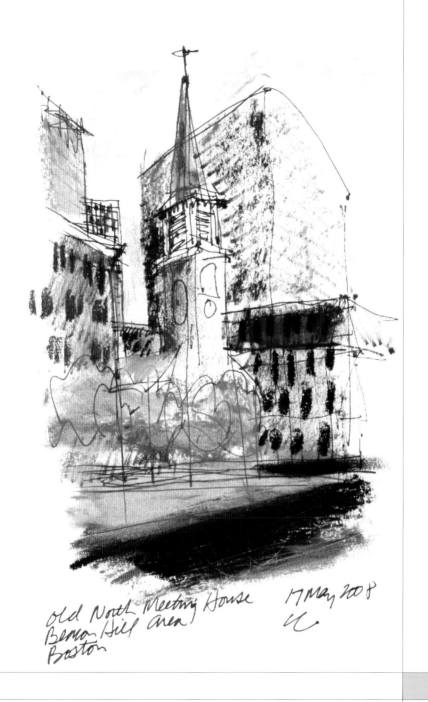

old North Meeting House
Beacon Hill area
Boston

17 May 2008

lines and mess will give your sketch that "hand-drawn"
appearance. No digital program can achieve this.

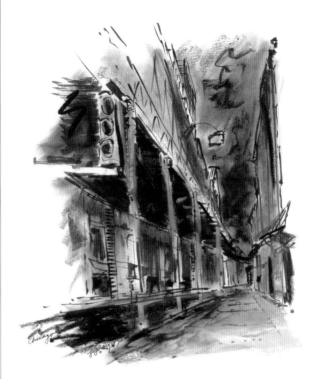

Night is drawn not by using black, but by using an overlay of several shades of dark blue, purple and pale violet.

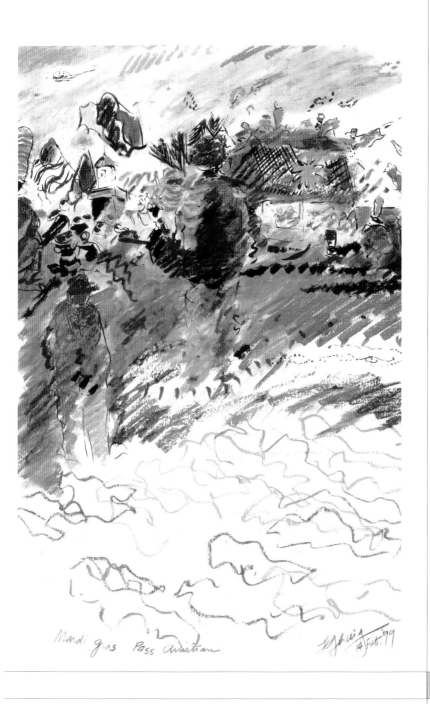

Mardi gras Pass Christian

14 Feb '99

rade motion can be captured in very quick hand
movements... you don't really think — it's more of a reaction
the event.

The "slow draw" images which you capture are not quick sketches, but drawings made when you have time to construct and add the types of visual cues which record place-making in more detail. The range of your images can go from cityscapes to close-up building detail, as shown in the Auditorium Building in Chicago. The use of color in both the cityscape and arcaded sidewalk communicates the materiality of the heavy, rusticated granite blocks. A helpful technique in place-making is to repeat a landmark feature in several of your drawings. This technique will provide the viewer with an easily recognizable cityscape image. Sears Tower (now Willis Tower) can be included in all of your Chicago cityscape drawings, no matter where your view is from.

"Slow Draw": Ample Time

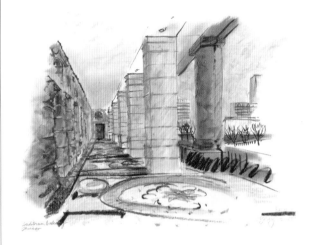

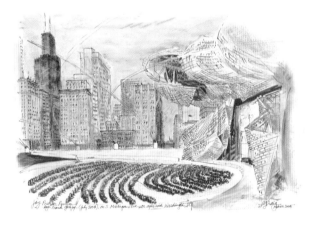

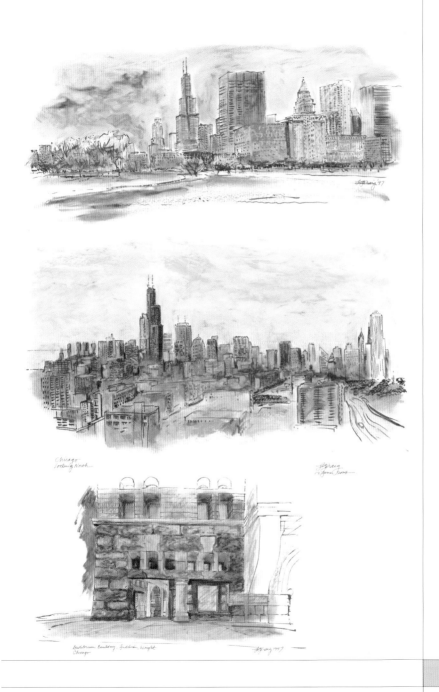

These drawings take time, so don't rush the effort. Draw in a large sketch pad while sitting on a park bench or looking out of your hotel window.

The season and time of day are shown in the Michigan Avenue "slow draw". Notice the autumn-yellow ochre color of the trees on the right. The viewer can tell that it is late afternoon due to the building shadows being cast on Michigan Avenue. Also, the pale pink and orange tinting of the sky shows that the sun has moved to the west.

Look closely at the end of Michigan Avenue and you will see the clock face on the Wrigley Building, as well as the twin towers of 900 North Michigan Avenue.

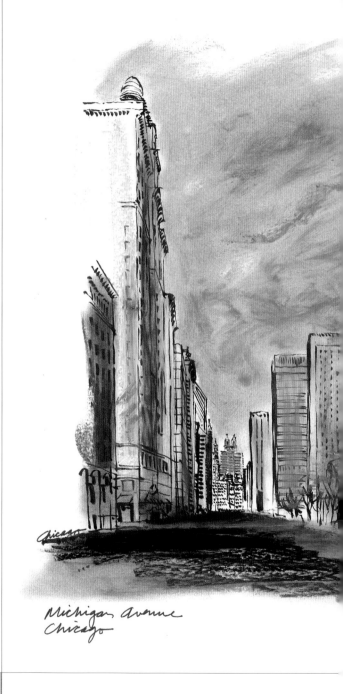

Michigan Avenue
Chicago

Yep, you can stand in the middle of a street and draw... just stay on the center island!

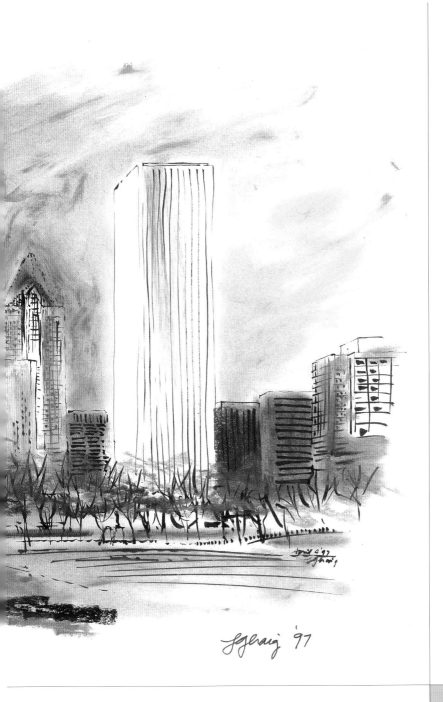

lgclaig '97

These two drawings, the Harbour Village Center in Porto Fino, Italy, and a city hillside pedestrian path in Genova, Italy, were first drawn on-site in pencil, then taken back to the studio to go over the pencil in ink, and then the pencil was erased to produce the final drawings. These types of drawings take time, but the end products are full of place-making detail. Every inch of the paper is full of visual information.

The drawing tool used here is a roller-ball pen on 18"x24" white Bristol weight paper.

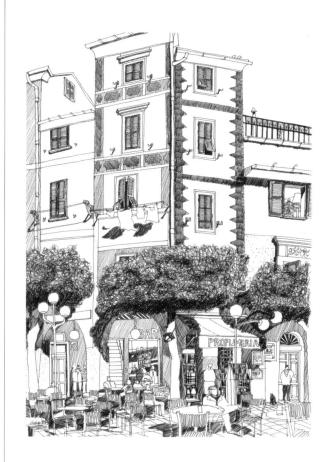

find the cat and the birdcage... add daily detail to your drawings!

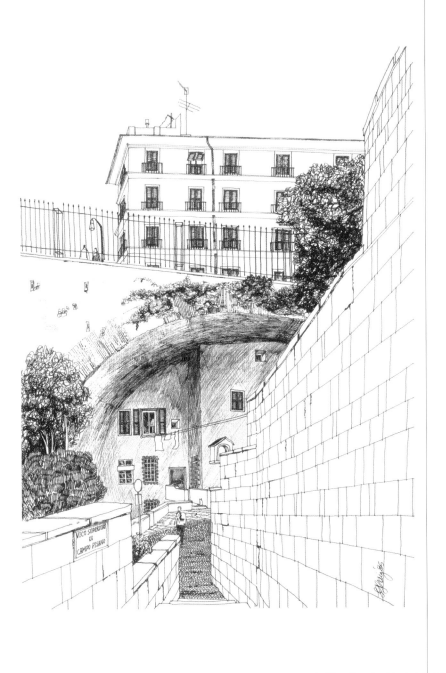

The pen gives you an opportunity to add considerable urbanscape detail.

These drawings, in oil pastel and brush pen, were completed during an architectural journey to Northern California. They are all drawn on-site in a large drawing pad of Bristol weight paper. A small, portable folding chair provided the author with room on his lap to rest the drawing pad on their lap during the execution of the work.

Pay particular attention to the variety of methods used to draw the sky. In the blue sky drawings, several tones of blue were overlaid and blended to add depth and richness of color.

The water was constructed using a similar technique, by overlaying and blending oil pastel colors. The San Francisco Bay has several shades of blue, with an added white oil pastel dragged across the drawing to give the appearance of whitecaps.

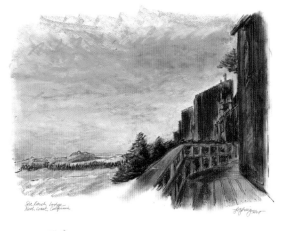

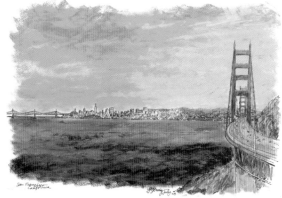

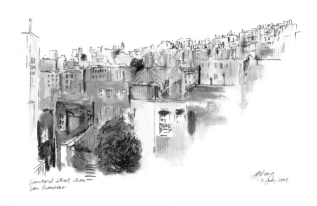

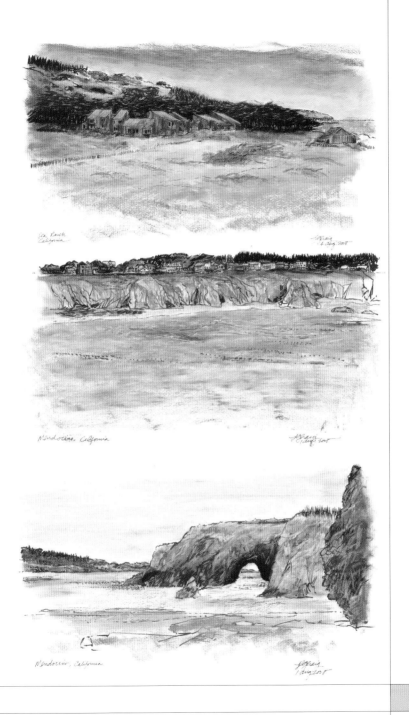

The water's edge along the pacific coast of Mendocino is
drawn using the same oil pastel color range as the land.

Extended architectural and landscape journeys to a particular region provide opportunities to develop cross-section perspectives of the landforms and built forms.

Try to capture as many settings as your drawing day permits.

As you travel from place to place, in a car or walking, stop and pause for a while to draw whatever is of interest to you.

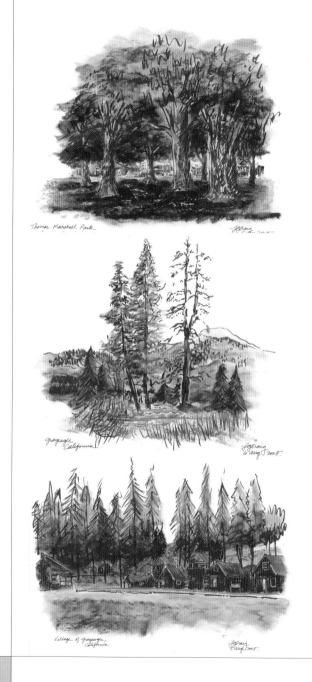

Thomas Marshall Park

Grayeagle California

Village of Grayeagle, California

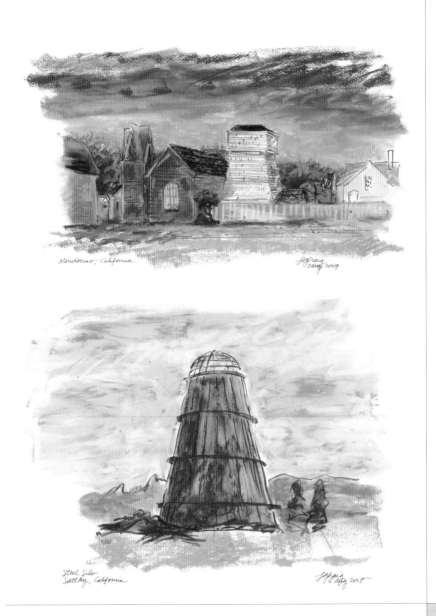

Mendocino, California

Steel Silo
Sutter Bay, California

This timber drying cone captured my attention out of the corner of my eye as we drove through the Sierra Nevada mountains.

The Circus Circus Casino in Reno was surrounded by a hot rod car show, causing the building and car colors to blend and complement each other.

Drawing the Lake Tahoe landscape and its range of earth colors provides a contrast to the interior of the casino.

Do not pass up the opportunity to draw all of the environments you encounter, as doing this will broaden your skill level

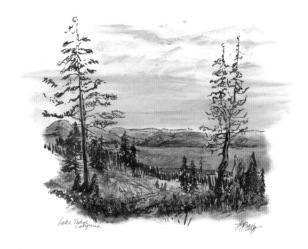

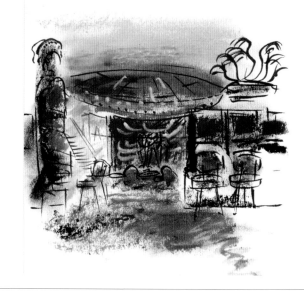

we all find ourselves in unexpected places when we draw.

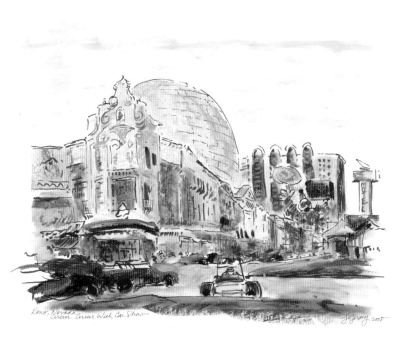

Reno, Nevada
Circus Circus Hot Rod Car Show

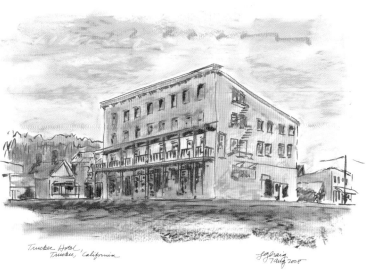

Truckee Hotel
Truckee, California

Regional landscapes take on a predominantly horizontal format, with drawings sometimes extending over several sheets to get the full view.

By slowly drawing traditional landscapes of New Mexico and upstate South Carolina, you gain an appreciation of their landforms and historical settlement patterns.

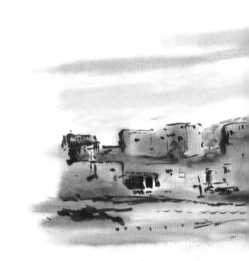

Taos Pueblo, New Mexico

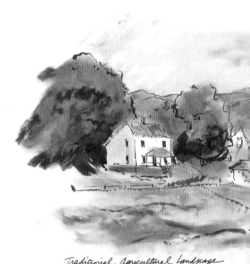

Traditional agricultural landscape
greer, sc.

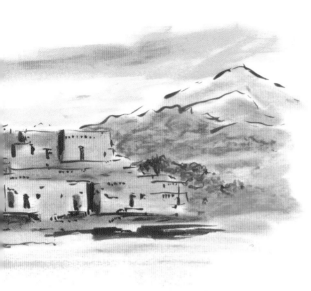

sgbraig '95

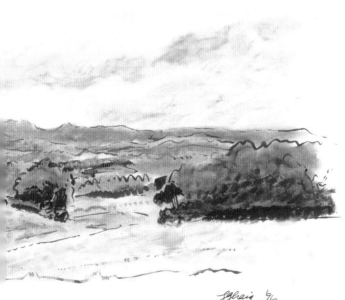

sgbraig '96

landscape drawings are best achieved using a large
drawing pad, which allows for wide, horizontal drawings.

there are many ways to use my house,
so the space must be strong than
anything in it, also the space must
be flexible + essentistic.

1970 - 85

you can't learn architecture at schools,
you learn architecture by doing architecture

Casa Unifamiliare
Lugano, Switzerland · M. Botta '81

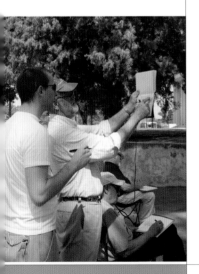

Track down your favorite buildings... and go
draw them... as shown here... "botto Hunt".

4. Drawing as a Way of Thinking

Developing hand, eye, and mind coordination is a process... the more you do it, the better you get. As a creative individual, you are continually presented with visual offerings to draw, and to take notes on what you are seeing. As you draw, you should try to dissect what you are looking at. Take it apart by using a variety of drawing conventions, such as plan, axon, section, and perspective. In most situations, you will not have ready access to many areas of the subject of your drawing. So, be content with drawing what you can see, use your skills to deconstruct what you cannot, and look at it from several angles.

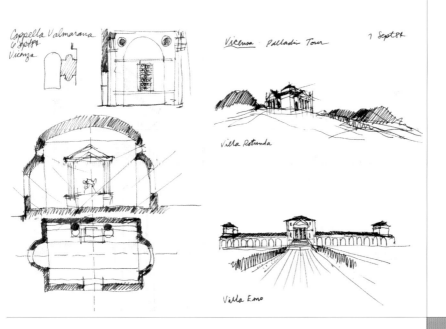

Cappella Valmarana
6 Sept 84
Vicenza

Vicenza · Palladio Tour 7 Sept 84

Villa Rotunda

Villa Emo

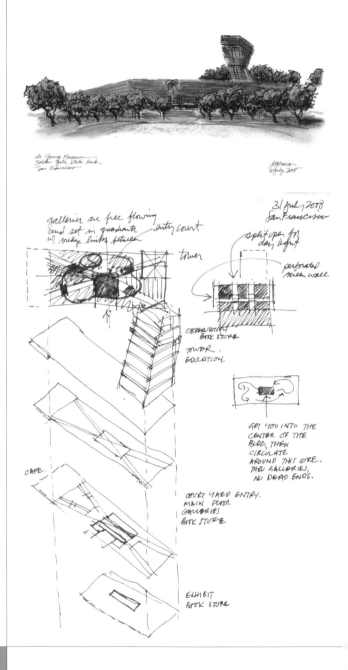

de Young Museum
Golden Gate State Park
San Francisco

31 Aug 2008
San Francisco

galleries are free flowing
and set in quadrants — entry court
w/ bridge links between

tower

split open for
day light

perforated
screen wall

OBSERVATION
BOOK STORE

TOWER.
EDUCATION.

GET YOU INTO THE
CENTER OF THE
BLDG, THEN
CIRCULATE
AROUND THIS CORE.
THRU GALLERIES,
NO DEAD ENDS.

CAPE.

COURT YARD ENTRY.
MAIN FLOOR
GALLERIES
BOOK STORE

EXHIBIT
BOOK STORE

Analytical Drawings

As you travel with the intent of developing your visual vocabulary, take notes as a design student, not as a tourist who only sees the surface.

The analytical drawing is annotated and accompanied by an inventory of diagrams, which dissect the building or landscape into its primary components. The goal is to simplify the graphic to show the essence of the place.

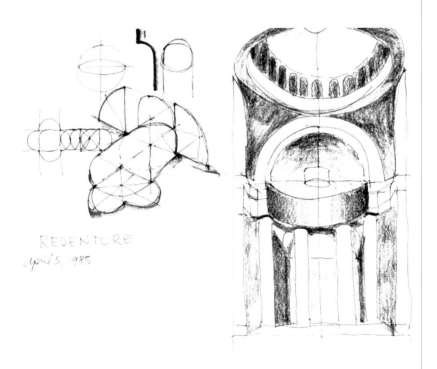

REDENTORE
april 5, 1985

use as many drawing conventions as you can to
analyze a place or a building.

Analytical drawings come in all shapes and sizes. Many times these drawings are made up on the spot, as these graphics were, done to analyze the Buckhead Library in Atlanta, Georgia. Here, the library has a direct axial visual connection with the downtown area, so it is important to record that view corridor.

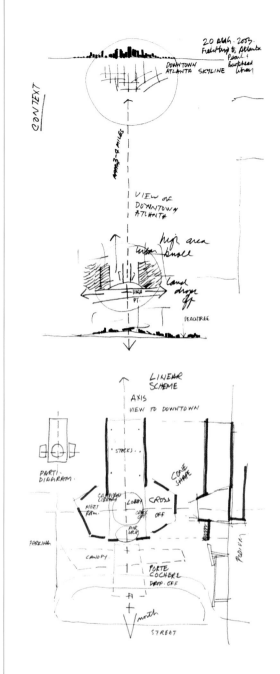

Look at the sequence of drawings and the different drawing tools used.

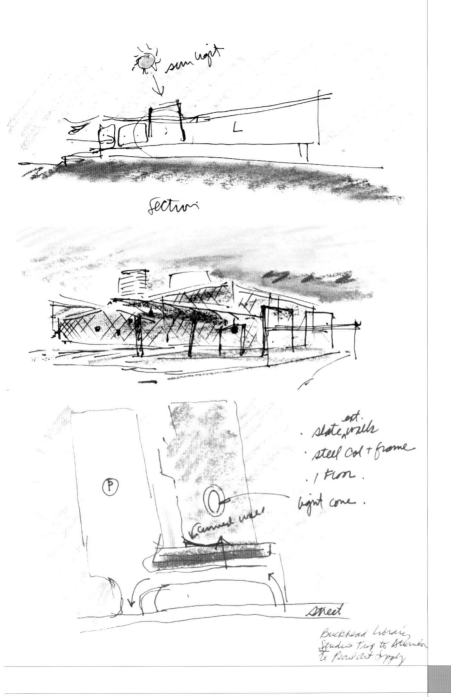

sun light

L

Section

· ext.
· slate walls
· steel col + frame
· 1 Floor.
light cone.

P

curved wall

street

Buckhead Library
Studio Trip to Atlanta
to Binders Art Supply

A quick site sketch with color added makes for a
powerful image!

The analytical drawing is a mixture of images and observation notes. As you are viewing a particular place, develop what I call "the architect's eye" for seeing, understanding, and recording its characteristics. These are notes to yourself to expand your memory bank of place-making. Call on all of your senses to produce a comprehensive annotated drawing.

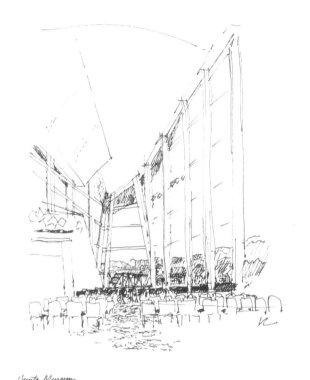

Hunter Museum
preparations for
6pm concert:
3 apr. 2008 overcast some rain

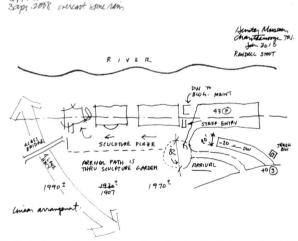

Hunter Museum
Chattanooga TN.
Jan 2018
RANDALL STOUT

RIVER

DW TO
BLDG. MAINT
43 Ⓟ
STAFF ENTRY
ACCESS
BRIDGE
SCULPTURE PLAZA
ARRIVAL PATH IS
THRU SCULPTURE GARDEN
ARRIVAL
TRASH
BIN
1990± 1930±/1907 1970±
linear arrangement.

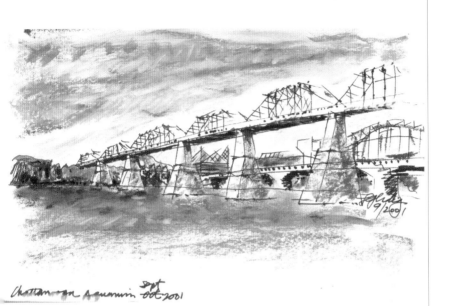

Chattanooga Aquarium ~~Sept~~ Oct 2001

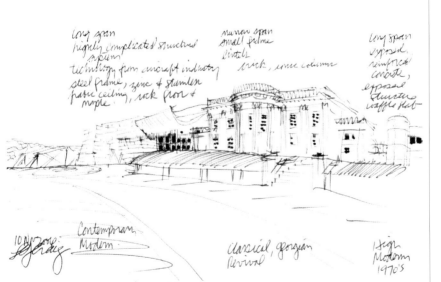

Long span
highly complicated structural
system
technology from aircraft industry
steel frame, zinc & stainless
fabric ceiling, rock floor &
maple

narrow span
small frame
lintels
brick, stone columns

long span
exposed,
reinforced
concrete,
exposed
structure
waffle slab

Contemporary
Modern

Classical, georgian
Revival

High
Modern
1970's

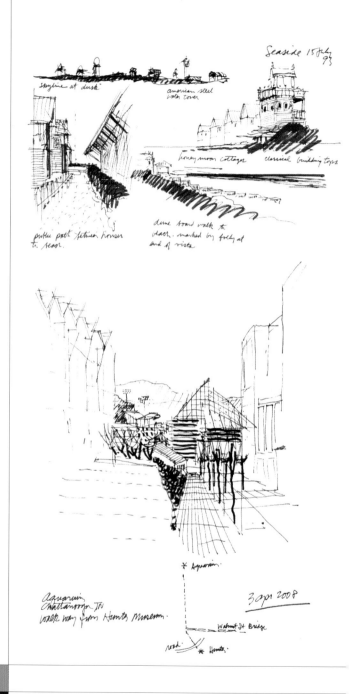

Seaside 15 July 93

skyline at dusk

american steel water tower

honeymoon cottages classical building tops

public path between houses to beach.

dune board walk to beach. marked by folly at end of vista

Aquarium
Chattanooga TN
walk way from Hunter Museum.

3 apr 2008

* Aquarium.

road

Walnut St Bridge

* Hunter.

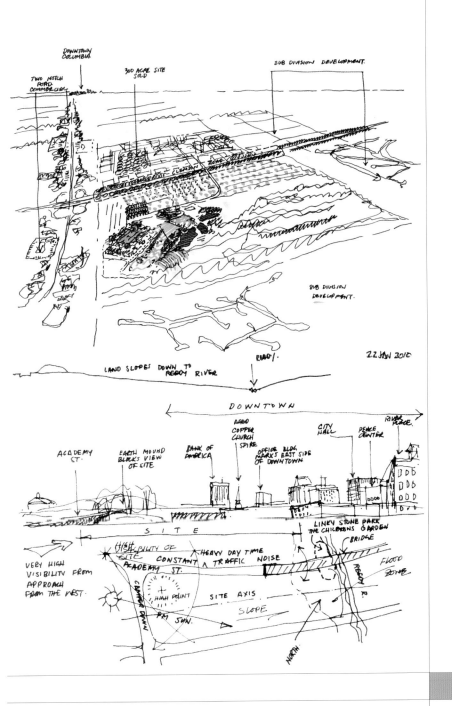

For the aerial sketch, hire a Cessna 170 for an hour, take photos, then draw it in your studio!

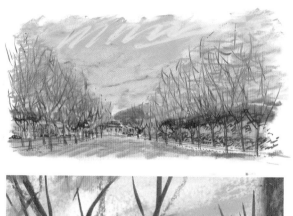

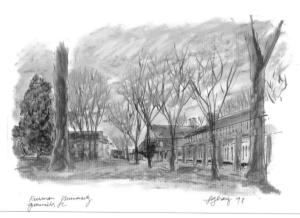

Furman University
Greenville, SC

SGraig '98

175

Sequential / Serial view Drawings

As you think through your design or planning project, consider the sequential drawing method as a means to visually communicate your proposal.

Initially developed by Gordon Cullen in his classic urban design book "The Concise Townscape", where the technique of "walking through an imagined place" was proposed, Cullen teaches us about visually recording the "here and there" of a place. The "here" is where you are standing to take in the view. The "there" is what you are looking at. This method of drawing is achieved by a series of images, getting closer and closer as you move through a space.

Notice in the drawings on the following pages that your view can either be straight ahead at street level or looking upward at roofs. Also, notice that figures can direct the viewer's attention to a particular aspect of the drawing that you want to communicate. Small things, like the angle of a head or a figure's arm pointing to the subject of the drawing, will bring your drawing to life.

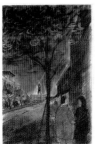
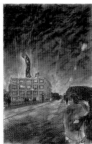
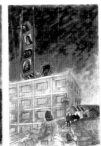

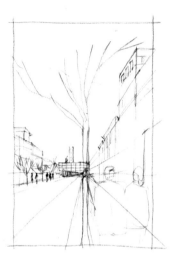

Draft on trace using
black prismacolor pencil.

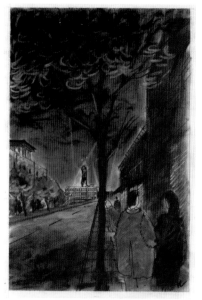

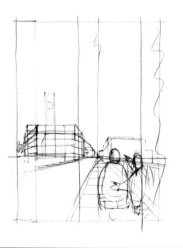

Final on
mylar using
prismacolor
and oil pastel.

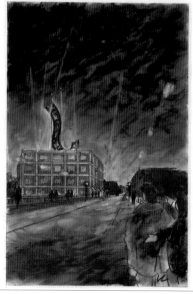

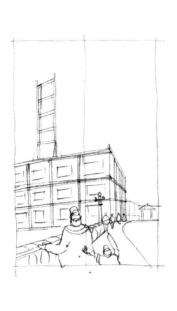
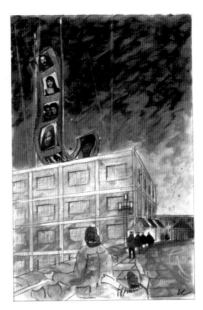
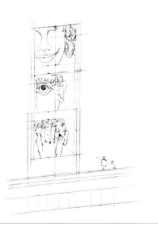
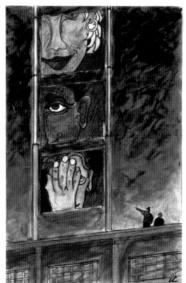

These sequential sets of black and white drawings show a simple exercise you can sketch. These are drawn on plain white 8$\frac{1}{2}$"x11" paper. Notice that the frame of reference of the landscape and townscape is a horizontal, rectangular box. They are drawn using a black roller-ball pen and a black Sharpie marker (fine point). These are imaginary places, so you can make them up as you go along and get closer to your "destination".

The landscape exercise starts with a distant view of your imaginary place and shows the dominant landform context. As we move closer in the next three images, your eye picks up the tree canopy sheltering a building. The Sharpie marker helps you to make simple line strokes to pick up glazing, tree canopy, and earth sections. The final image shows scale and proportion.

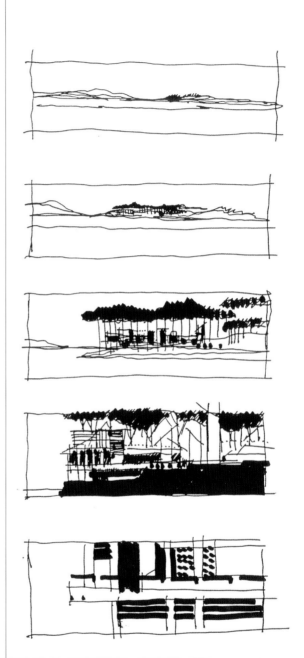

The townscape exercise starts with an overview of a city of your imagination. As we get closer, your eye sees a large archway under tall buildings, and we emerge to view a large plaza with a landmark beyond it.

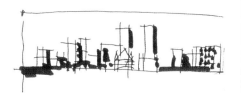

Try these exercises several times, all with different imaginary places, to get a feel for sequential drawings.

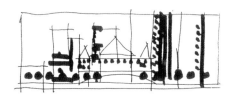

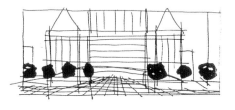

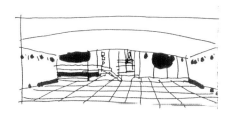

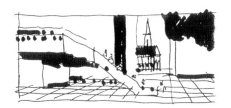

Make your own drawing exercises — use black sharpie and black roller-ball pen. Notice the simplicity of the images.

Frank Lloyd Wright's Auldbrass farm complex in Yemassee, South Carolina, is illustrated to show how very simple line strokes, made with the black brush pen then overlaid with oil pastels, are used to achieve the sequential walk-through of his farm.

The top left image captures the horizontality of the land, with the live oak trees forming a uniform, continuous canopy. An outbuilding is seen next, with its dark red-brown stained siding surrounded by vegetation. Look closely at the next exterior cypress wall. FLW battered his walls at nineteen degrees, with the board and batten also laid at nineteen degrees. If you were to get closer to the buildings, you would see that the brass flathead screws are also rotated nineteen degrees to the vertical.

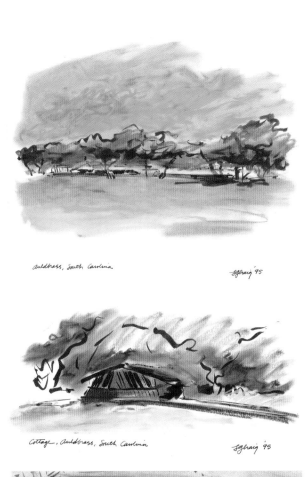

auldbrass, South Carolina sgbraig '95

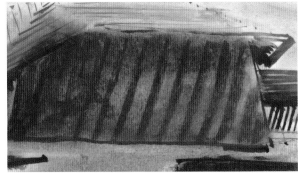

Cottage, auldbrass, South Carolina sgbraig '95

sequential drawings give you an overview... the lay of the land.

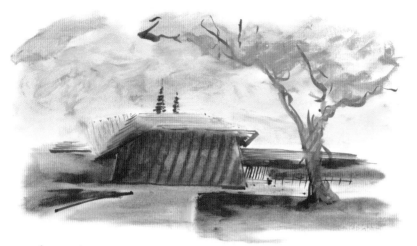

Barn, Auldbrass, South Carolina

sgcraig '95

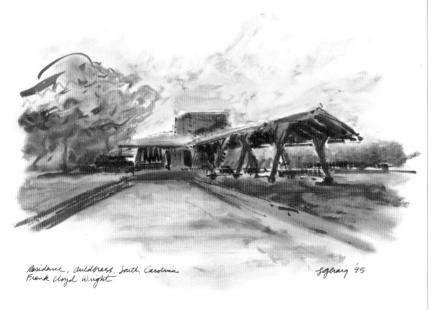

Residence, Auldbrass, South Carolina
Frank Lloyd Wright

sgcraig '95

As you get closer, more detail appears.

Returning to Auldbrass, details, the focus of attention was on the copper roof and rain water leaders.

The Auldbrass farm complex is a perfect example of what the term "organic architecture" means when discussing the design philosophy of Frank Lloyd Wright.

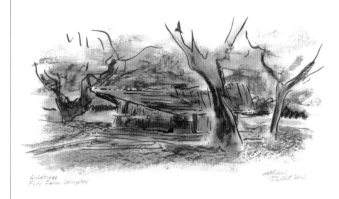

Auldbrass
FLW Farm Complex Hubbard
22 Oct 2010

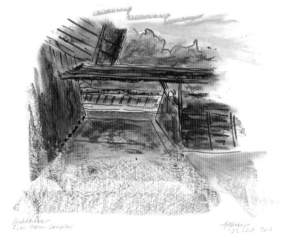

Auldbrass
FLW Farm Complex Hubbard
22 Oct 2010

Frank Lloyd Wright and Mies van der Rohe had one thing in common...

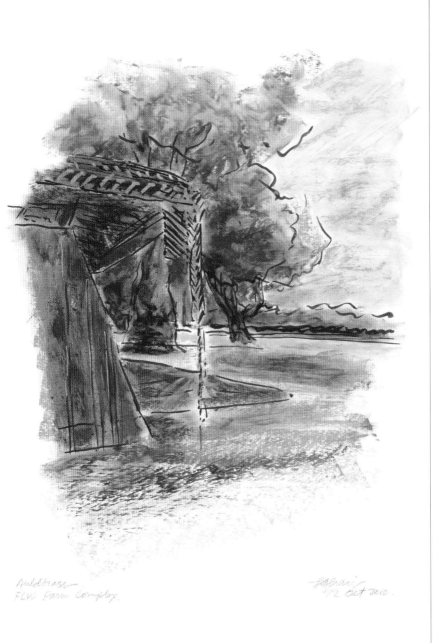

Auldhouse—
FLW Farm Complex.

ff Brun
2 Oct 2010.

They knew how to place a building in the landscape.
Check out the Farnsworth House.

You can experiment with different vantage points when developing your sequential drawings.

Illustrated here are two university central courtyards: The Horseshoe at the University of South Carolina and Harvard Yard. Each of these courtyards, sometimes referred to as malls, are linear, rectangular spaces.

By standing at one end of the courtyard, the first view is drawn. Then, by pivoting 90 degrees to the left and right, the corner entry paths are drawn, showing the space contained in-between the academic buildings.

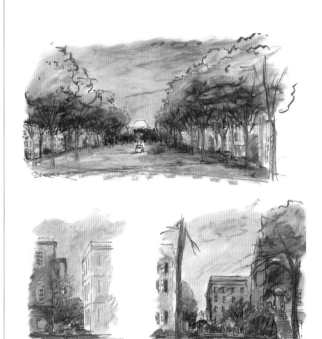

The Horseshoe
University of South Carolina

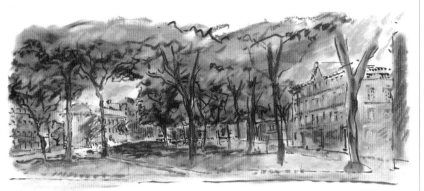

Harvard Yard
from Holworthy to grays

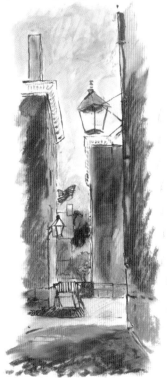

Harvard Yard
from Holworthy to Stoughton, Brooks and Mower

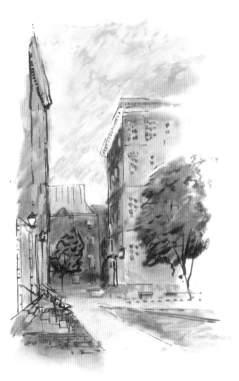

Harvard Yard
from Holworthy to Thayer and Canaday

SFCraig July '98

walking and drawing university campuses develops your
understanding of grouping buildings together as a
cohesive whole.

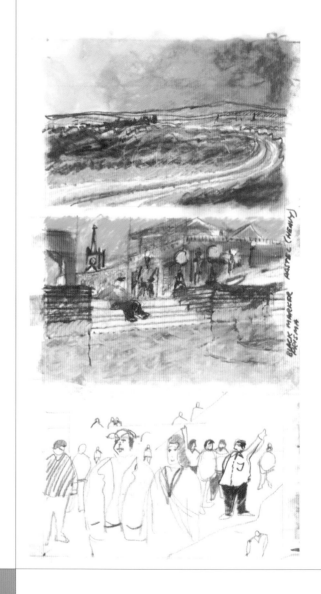

Developing Design Proposals Using the Storyboard Method

The method of visually scripting a proposed story has been used by cinema producers and advertising design studios for many years.

The idea is to chart the graphic flow of visual information on a series of blank frames from the beginning to the end. You can imagine the quantity of storyboard images that comprise a full-length theatre film of two hours!

Start by thinking about what story you want to tell as you walk through your proposal. These initial images are quick drafts in pen or pencil, some with limited color. The storyboard images want to be linked together to indicate a "flow" through a space.

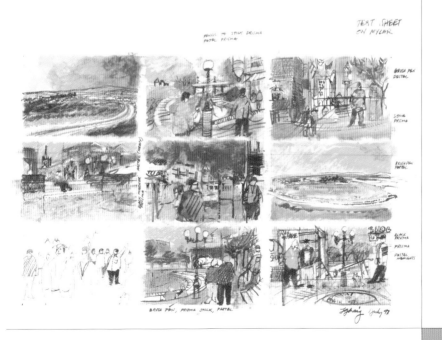

The storyboard is commonly used in the advertising industry and when drafting scenes of a movie.

One sequential drawing exercise, which can be achieved while sitting in your auditorium during a lecture accompanied by digital graphic displays augmenting the speaker's presentation, is to draw the lecture images very quickly. These images should be quick, stylized scribbles with some notes.

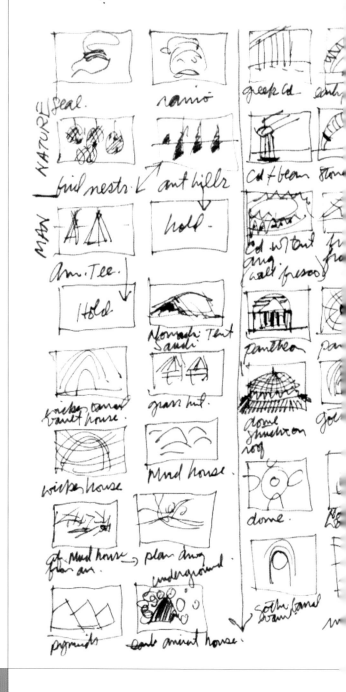

This storyboard was made during a lecture given by architect Frei Otto, as he discussed the origins of his tensile structures.

vault

Flower Catt | Flower Catt | Small steel roch | Crystal Palace London

Istanbul Sophia | Russian Church | glass dome modern | steel dome vault over assembly hall

Oriental dome. bamboo. | | Civic Bldg. | Circus tent

India Palace. | India Tent water | Cat Structure | steel tower

St Pauls. | St Pauls London | steel tower | germ. Mosque

Isfahan Mos. | Jerma Rozochen | Nervi | geodesic dome. Fuller.

| | Banshan. | early tent structure

gaudi | gaudi Sagrada Familia

The next six pages of this book show the sequential drawing development of an urban design proposal. The images start out as sketch ideas, and are annotated to explain to the viewer what is taking place in the proposal.

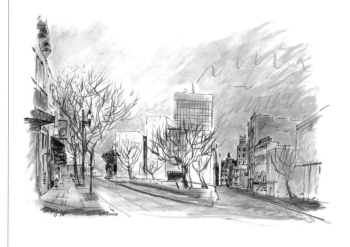

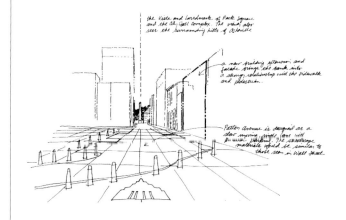

the Vista and Landmark of Pack Square and the City Hall complex. The view also sees the surrounding hills of Asheville

a new building extension and facade brings the bank into a strong relationship with the sidewalk and pedestrian.

Patton Avenue is designed as a slow moving single lane with on each side. The streetscape materials would be similar to those seen on Wall Street.

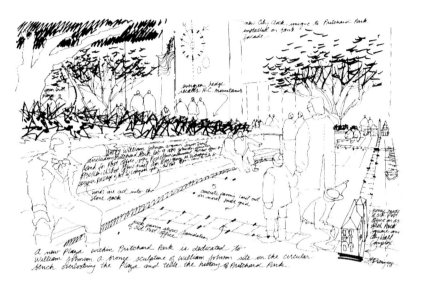

A new Plaza within Pritchard Park is dedicated to
William Johnson. A bronze sculpture of William Johnson sits on the circular
bench overlooking the Plaza and tells the history of Pritchard Park.

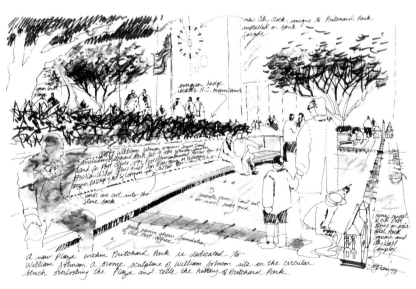

A new Plaza within Pritchard Park is dedicated to
William Johnson. A bronze sculpture of William Johnson sits on the circular
bench overlooking the Plaza and tells the history of Pritchard Park.

In these sequential drawings, three critical compositional components are in play:

Foreground: Elements near the viewer, where visual detail enhances the message.

Middle Ground: Elements which are halfway between the viewer and the far side of the drawing.

Background: Distant elements and forms are shown in a vague manner with not much detail.

By constructing your drawing with these three components – foreground, middle ground, and background – you will be able to achieve depth.

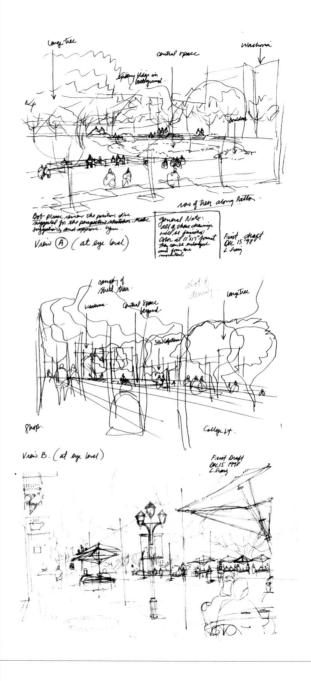

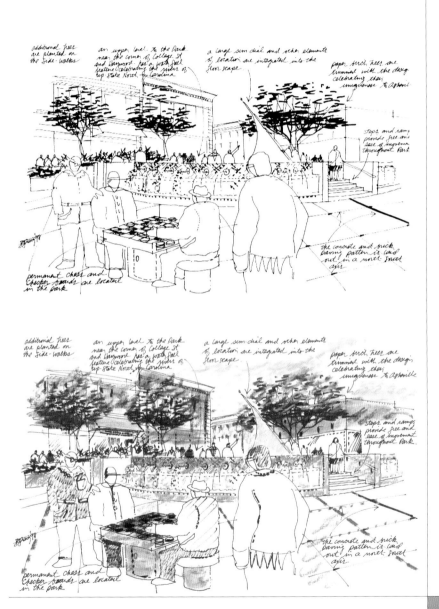

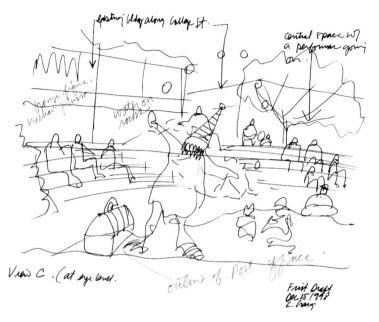

existing bldg along College St.

central space w/
a performer going
on.

large figure
William Watson

water on
rocks on

View C . (at eye level.

outline of Post office

First Draft
Dec 15 1998
L. Craig

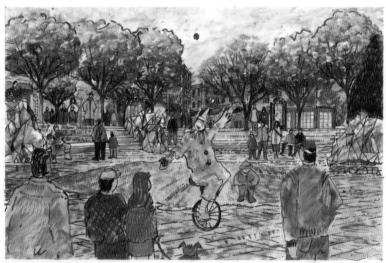

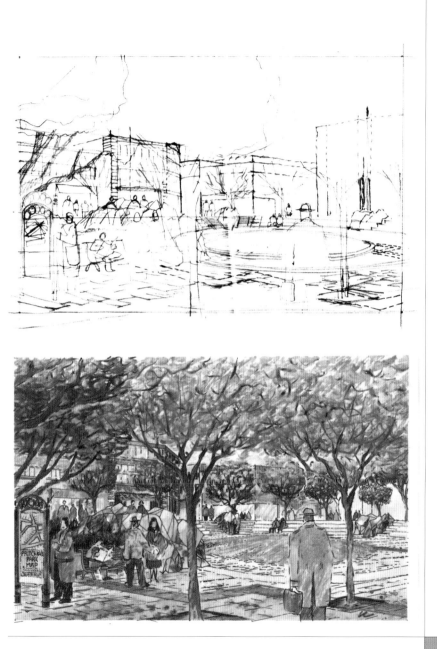

I always find it interesting how the people I draw to help explain an urban space come alive with their own personalities.

The final storyboard
of sequential drawings
takes on a variety
of urban scales
and subject matter.
Some designers
have researched
and speculated that
most people can best
understand small-scale
proposed ideas, similar
to the small vignettes
shown here.

Large urban context
illustrations need
to include familiar
landscape and
townscape components.
The familiar objects are
quickly identified by the
viewer, and this begins
the recollection and
understanding process.

Designers must know
the "placeness" of a
proposal very well in
order to incorporate
these ingredients into
their drawings.

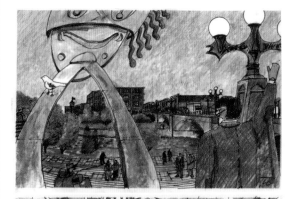

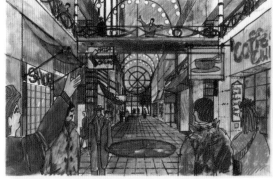

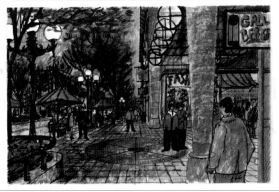

sometimes, people understand small details better than large master plan designs.

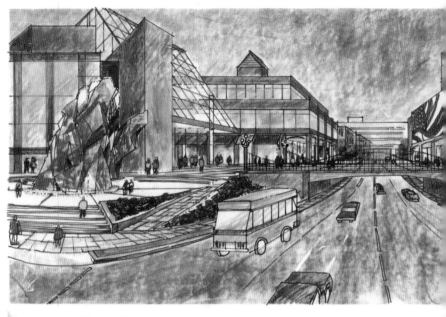

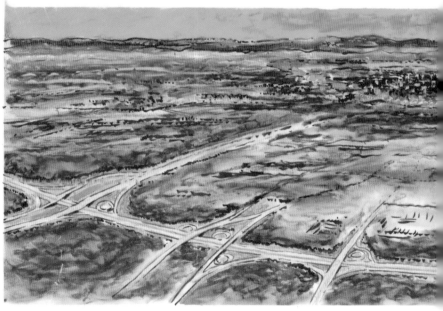

Never allow your paper to control the size
of a drawing.

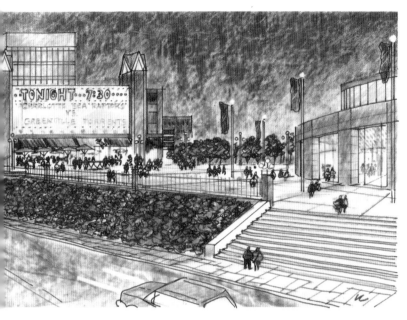

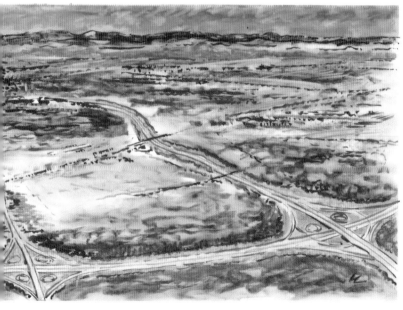

A sequential drawing series can start with an aerial
perspective followed by a "view from the road".

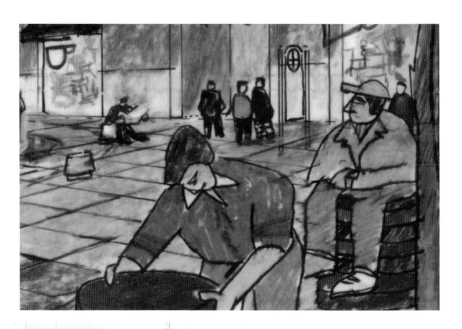

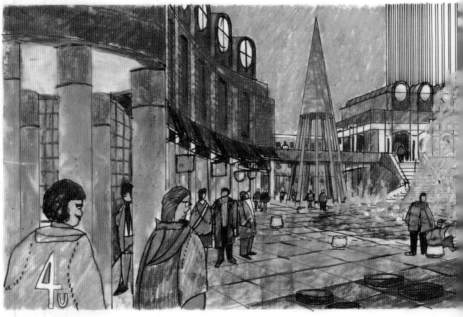

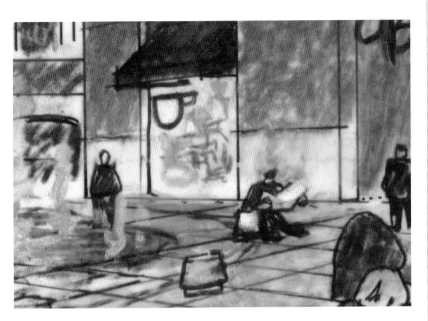

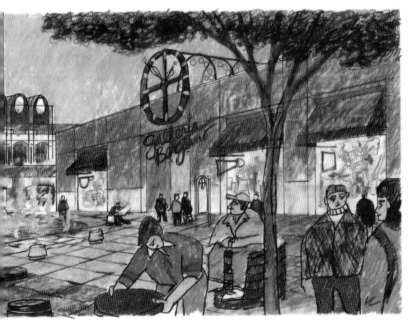

you are working toward creating design images that capture the spirit of a place...

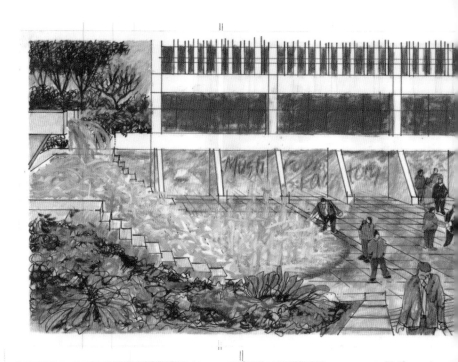

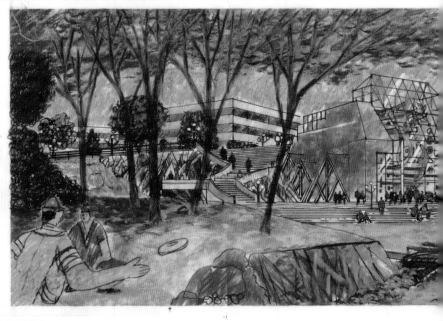

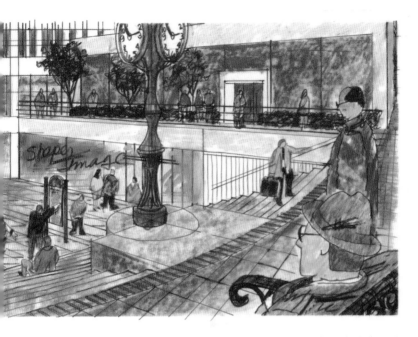

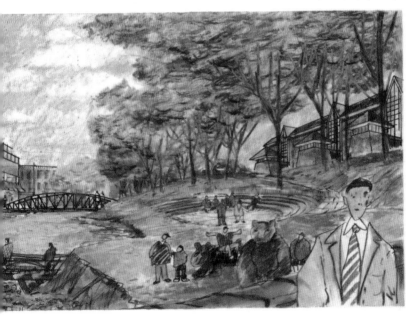

Today, water in urban places becomes interactive and participatory. People like to touch water.

Afterword

The intent of this little reference workbook is to show the variety of drawing tools available to you for creating both quick sketches and longer, more detailed drawings. In addition, it shows different techniques that can be achieved with these tools, as well as a variety of graphic communication methods.

The pages of this workbook are cross-referenced with color coding, graphic images, and text explaining how the drawings were created.

The author hopes you have enjoyed this drawing workbook, and that it will always be one of your favorite tools in your travel bag.

Remember... just Draw It!

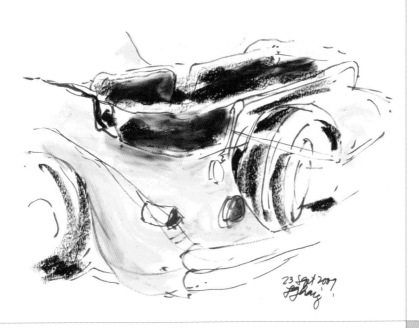

23 Sept 2007